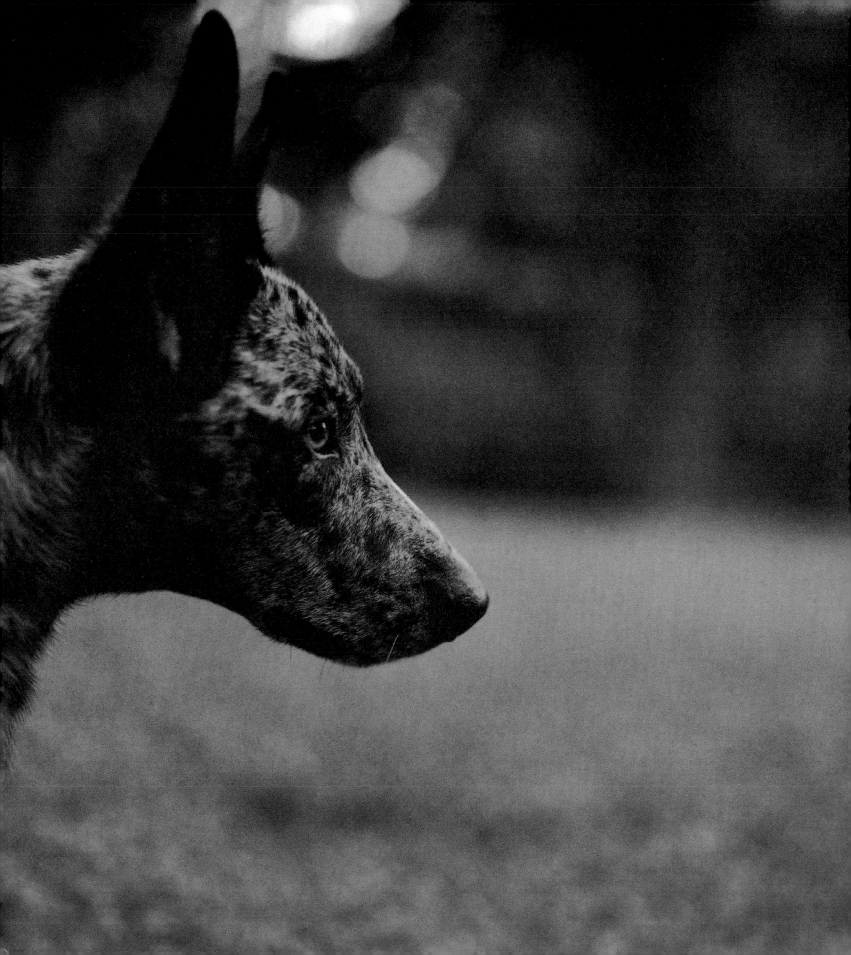

Photographs by
Keith Carter

bones

CHRONICLE BOOKS
SAN FRANCISCO

Printed in Hong Kong.

Library of Congress Cataloging-in-Publication
Data:

Carter, Keith, 1948–
 Bones / photographs by Keith Carter.
 p. cm.
 ISBN 0-8118-1258-8 (hc) . —ISBN 0-8118-1282-0 (pb)
 1. Photography of dogs. 2. Dogs—Pictorial works. I. Title
 TR729.D6C55 1996
 779' .32—dc20 96-3181
 CIP

Cover photographs: *Catahoula,* 1990 (front)
 Short Hair, 1995 (back)
Page 2: *Road Dog,* 1992

Distributed in Canada by Raincoast Books,
8680 Cambie Street
Vancouver, B.C. V6P 6M9

10 9 8 7 6 5 4 3 2 1

Chronicle Books
275 Fifth Street
San Francisco, CA 94103

Book and cover design: Tenazas Design San Francisco

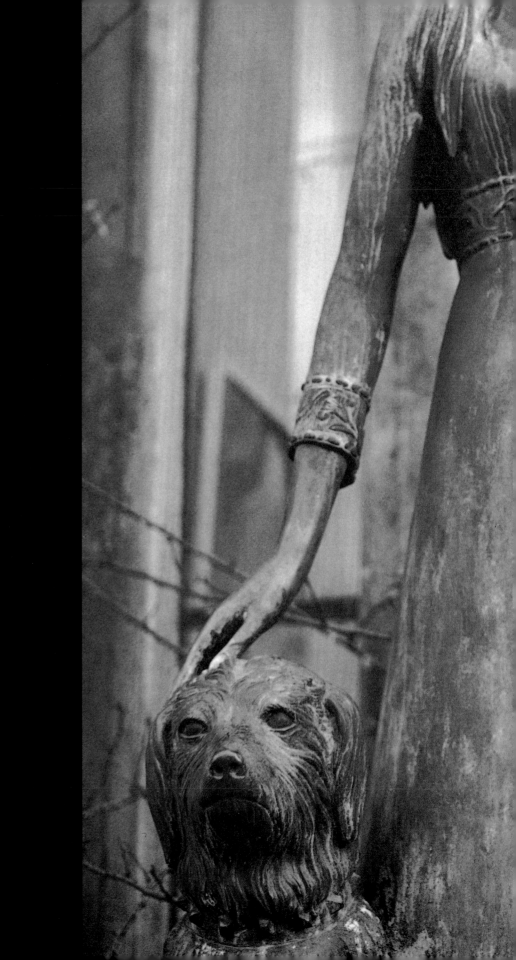

Introduction

"The animal shall not be measured by man.

In a world older and more complete than ours,

they move finished and complete, gifted with extensions

of the senses we have lost or never attained,

living by voices we shall never hear.

They are not brethren,

they are not underlings;

they are other nations,

caught with ourselves in the net

of life and time,

fellow prisoners of the splendor

and travail of the earth."

The Outermost House
Henry Beston

Of all the photographs I live with, my favorite sits beside my bed. It is a sepia-toned black and white print I bought at a flea market. Its history is lost to me, but it appears to have been made in the early part of the twentieth century. In it, a small dog, perhaps a terrier mix, sits alone in the spare and dignified pose popular with portrait photographers of that era. He is seated on a table covered with a medallion-patterned rug, which both softens and formalizes the photograph. He is an old dog, grown stout with age. His eyes bulge slightly and his muzzle has silvered. Ears folded back, he stares slightly off camera, presumably at his master. His expression is one of quiet acceptance, coupled with a resigned, been-around-the-block look.

It is my favorite for two reasons. First of all, it illustrates what a wonderfully democratic medium photography can be. All creatures great and small are equal before the lens. No subject is less important than another; given weight by the significance the photographer places on it. But mostly I like this picture because someone valued their elderly dog enough to take him to the studio of The Statham Brothers of Weedsport, New York, to have not just a snapshot, but a *portrait* made.

I have lived all my life with dogs and confess a deep and abiding affection for them. I have read with great interest recent books such as Elizabeth Marshall Thomas' lovely work, *The Hidden Life of Dogs,* and the startling *When Elephants Weep: The Emotional Lives of Animals* by Jeffrey Moussaieff Masson and Susan McCarthy. I am fascinated by these explorations into the complex interior lives of animals. Ultimately, however, I have been more moved by less-than-scientific material.

There is a legend in East Texas, thought to be African in origin and transplanted to the Southern culture with the arrival of slaves. The legend, embodied in countless folktales, tells of a dead soul returning in the form of a dog to protect and comfort its loved ones in times of trouble. In 1981 Texas filmmaker Ken Harrison created a small jewel of a film titled **Hannah and the Dog Ghost**, a part of his Texas Trilogy. In the film these words are spoken by the narrator:

" . . . When she looked into the eyes of that creature,
she knowed what it was.
Sure enough, the spirit of her man was beside her
now in the shape of a dog.
And if there's anything that can give meanness
a run for its money, it's a Dog Ghost
protecting somebody it loves."

A strikingly similar image has been described by the Swedish poet Artur Lundkvist. In 1981 Lundkvist suffered a near-fatal heart attack and fell into a coma. After two months, he began slowly to emerge into a state of semi-consciousness, during which he existed in a heightened dream state where his imagination soared while his body remained immobile and near death. He wrote of the experience in a small book titled **Journeys in Dream and Imagination**.

It is the dog returning, the same dog or a different one,

a shadow dog I cannot clearly perceive,

it has no definite form or color,

it approaches me somewhat threateningly, with a purpose,

but then it becomes uncertain, hesitates,

lies down or turns around,

starts walking away, but remains silent.

During these dream journeys, Lundkvist never makes actual contact with this "shadow dog," is never clear as to the dog's purpose, but feels "… as if it were a part of my own destiny."

From Paleolithic cave paintings to the dog/god who led ancient Egyptian souls to the afterlife, the dog has occupied a singular place in world mythology. Cerberus, the three-headed hound in Greek mythology, guarded hell to keep the living out and the damned in. In the Far East dogs appeared as temple guardians in ancient times, while the Egyptians also worshipped Sirius, the dog-star.

The dog-god may have disappeared, but there are still dog-heroes, such as Grayfriars Bobby, a devoted terrier who, for fifteen years, sat at his master's grave daily. We have found practical uses for the intelligence, trust, and friendship of our close companions. Airedale terriers carried messages between the trenches in World War I, while in World War II dogs filled various roles, including service in the parachute corps.

There are said to be over fifty million companion dogs in the United States alone, and there must be at least that many dog stories. One of my favorites is told by my wife, Patricia. It is a childhood memory of her uncle and a huge, rangy, spotted hound named Big Boy. The uncle was a barber and spent his days in his small shop. No one knew where Big Boy spent his days, but on certain occasions he would appear at the shop and take up a position as if waiting for a

chair. After a time, the uncle would take a nickel from his pocket, wrap it in a piece of paper, and offer it to Big Boy, who would take it carefully in his mouth. The big hound would then trot purposefully down the street to the meat market and buy himself a bone.

The thing that makes this more than just a pleasant dog story is the extraordinary fact that the butcher in that small town meat market was a blue man. At some point in his life, for mysterious and largely unexplained reasons, the man's skin had turned blue and remained so for the rest of his life. The locals briefly noted the change but met it with serene acceptance, as if every small town should have at least one blue man.

The visual image of a spotted hound and a blue man is a powerful one for me, but even more compelling is the idea of the *transaction*—the fair exchange—between the two. That idea has been much in my mind as I have worked on the photographs in this book.

Part of the power of photography is how it deals with memory. For me, the art of photography has always contained an element of magic. Use the camera well, murmur the right words, and it is possible to conjure up proof of a dream.

And so I have followed dogs under porches and down dirt roads and up cotton rows. The journey has been an intuitive exploration into the possibility of a commonality of spirit and a shared vision of the world. Many behavioral scientists seem now prepared to say that dogs and much of the animal world have an informed consciousness and an emotional life. Is it too improbable a leap to suppose they might also have a spiritual life? One not defined by human sensibilities?

Making these photographs has often seemed to me like a kind of dance. Often I have danced badly and the world has fallen apart at my feet. But sometimes the dance has gone well and my subject and I have moved together as if with shared purpose. At times I have felt both a sentient power and a spiritual presence in the dogs I have photographed. Sometimes, eerily, I have felt an intimation that our roles might be interchangeable. I think of these lines from the poet **Wendell Berry**:

"...all creatures,

passing in and out of life,

who move also in a dance, to a music so subtle and vast
that no ear hears it

except in fragments..."

— **Keith Carter**

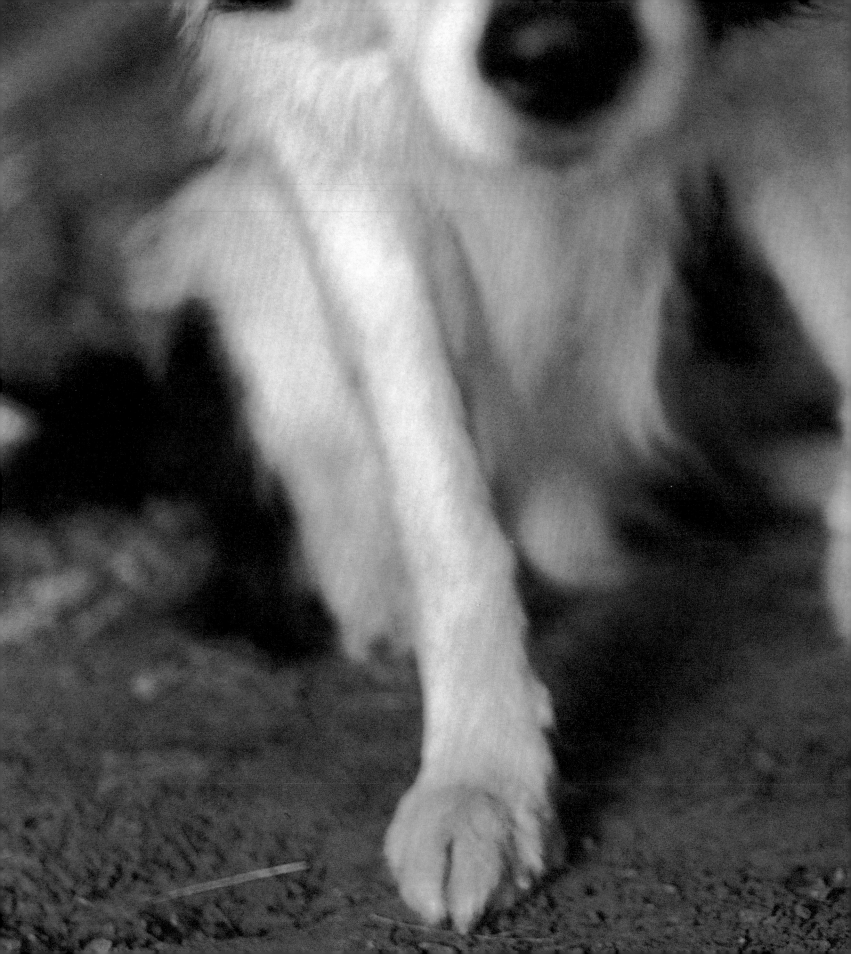

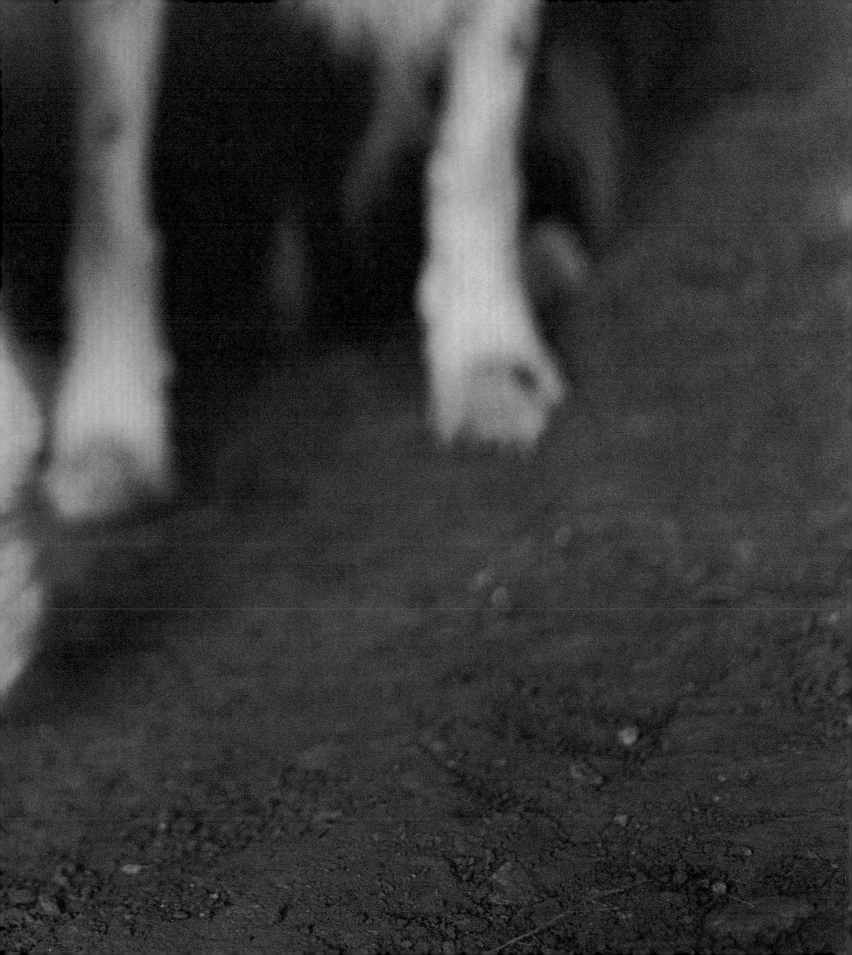

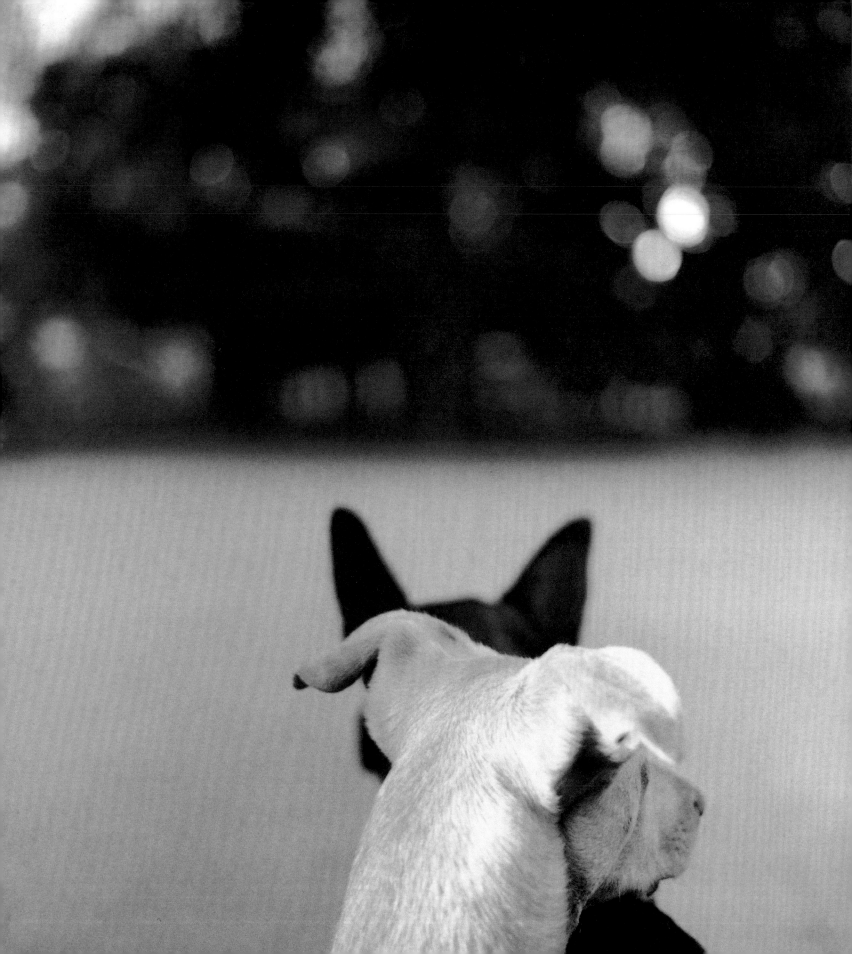

Watching **1995**

Alice **1994**

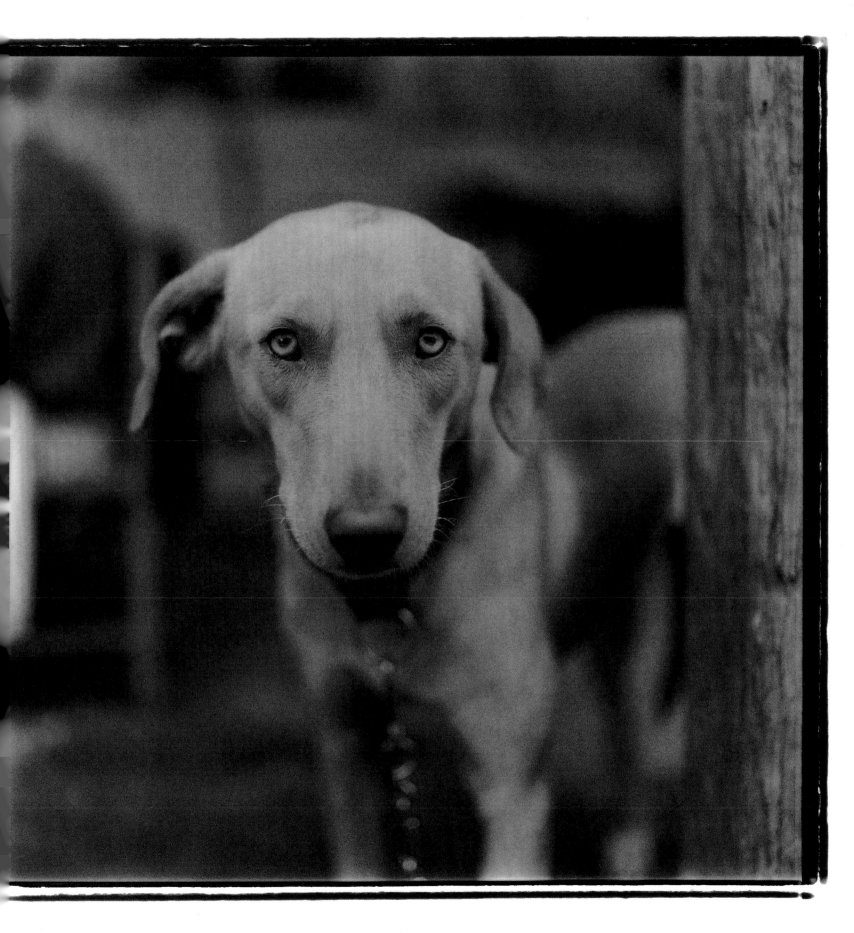

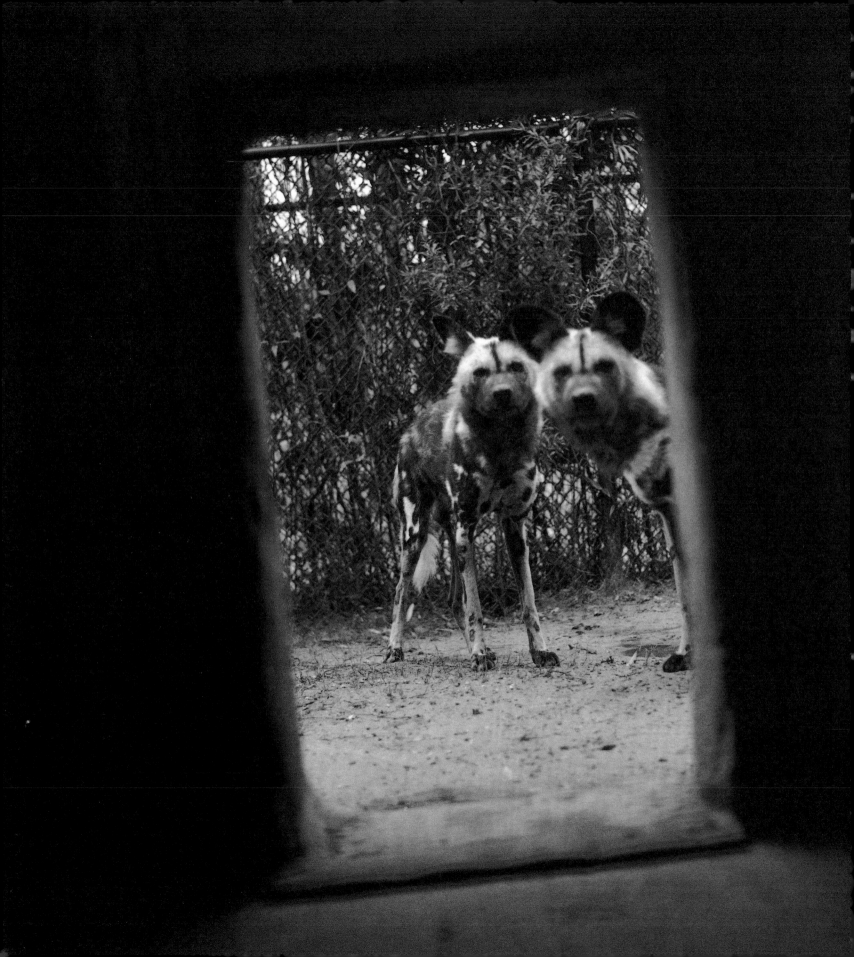

Wild Dogs **1994**

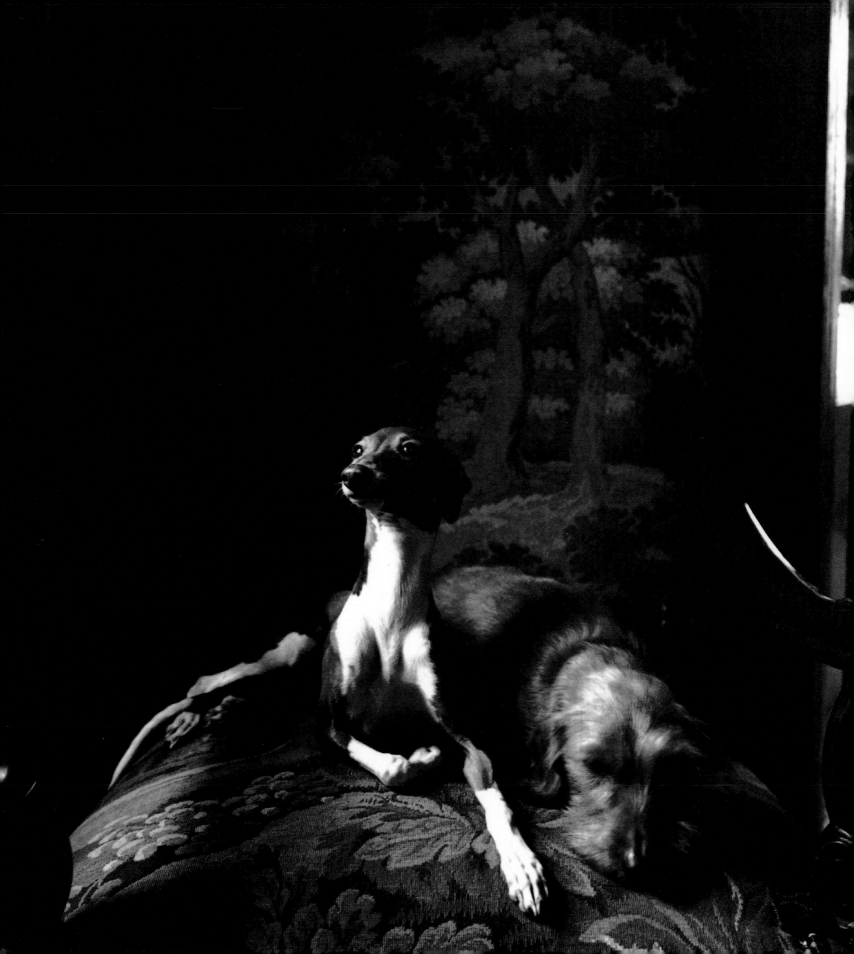

Giselle and Popeye **1987**

Sam **1988**

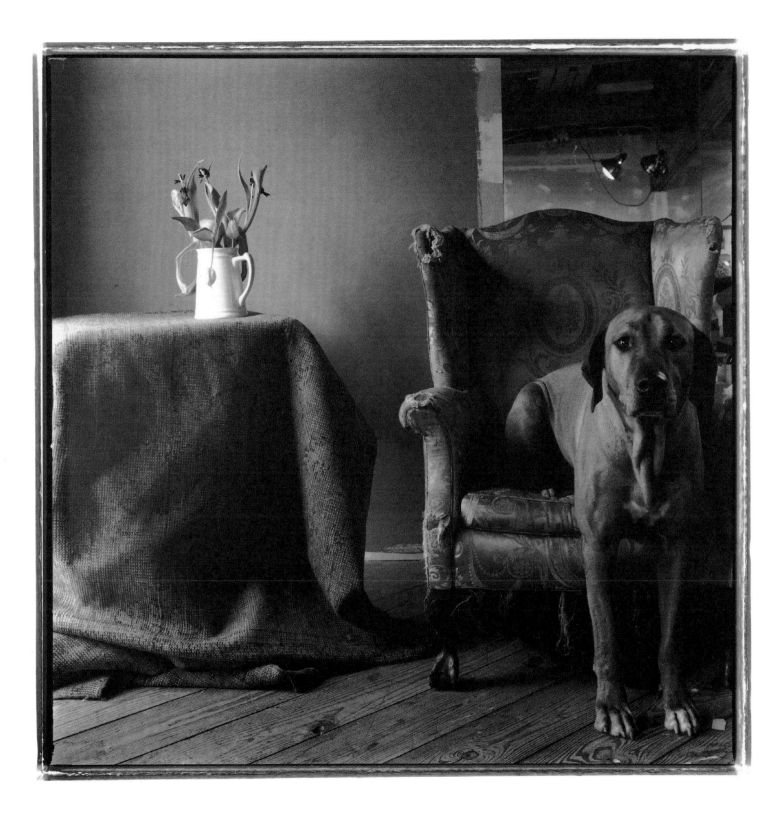

Isabel **1995**

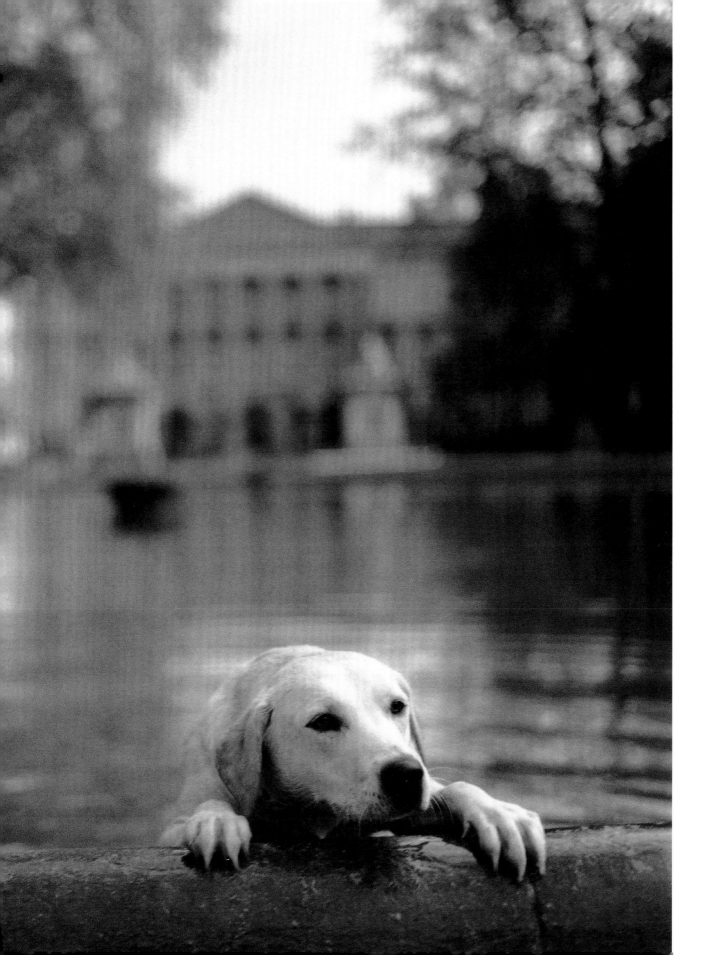

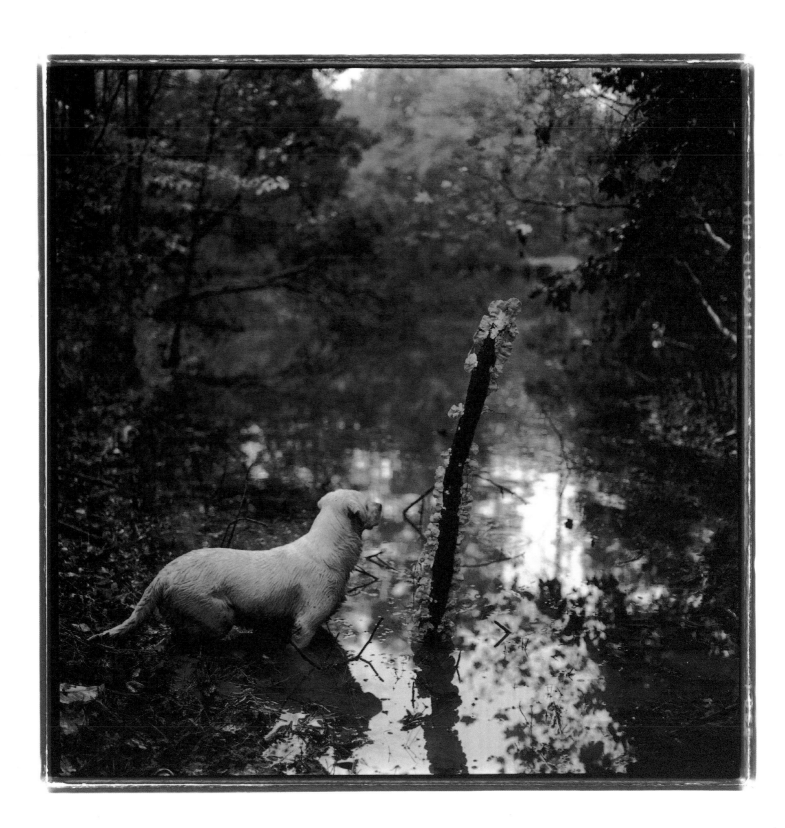

White Dog **1989**

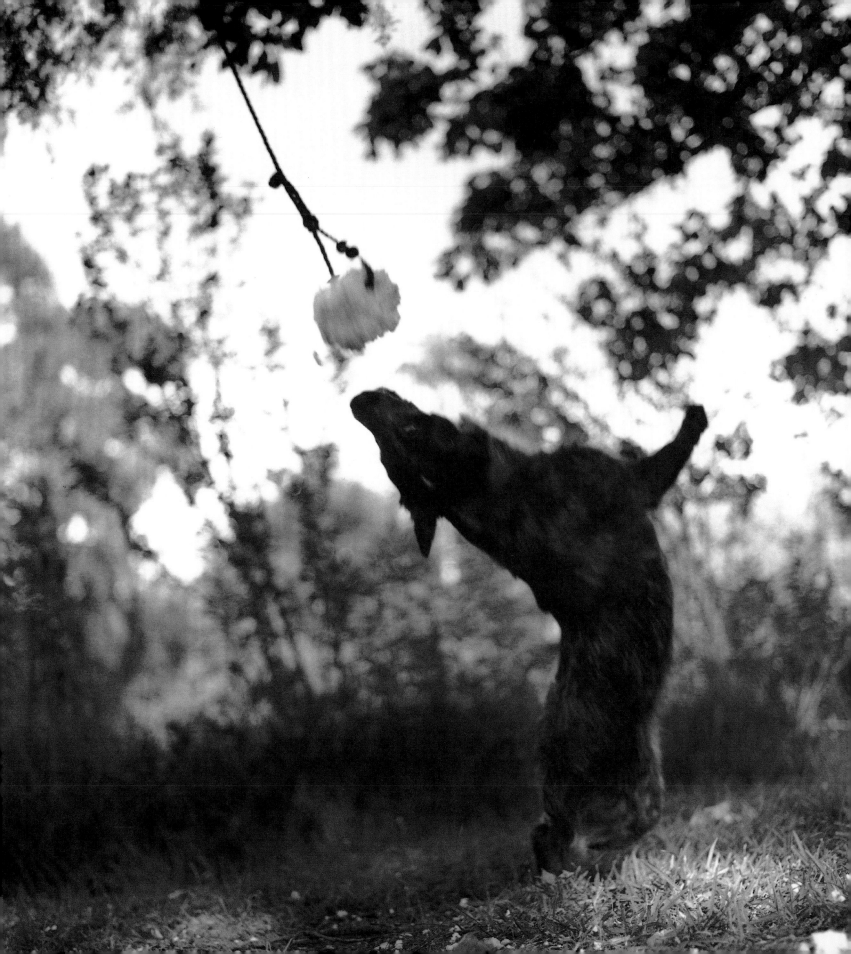

Suzy **1995**

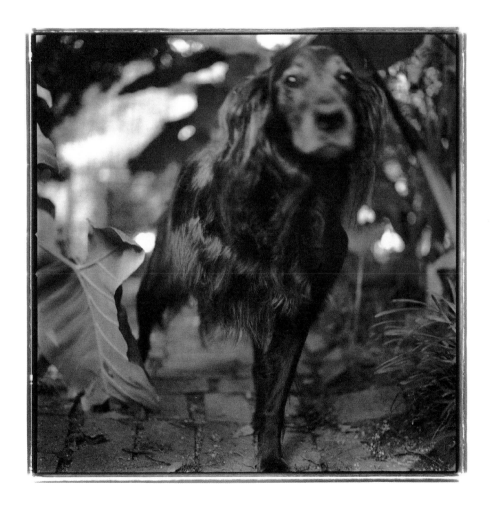

Tripod **1995**

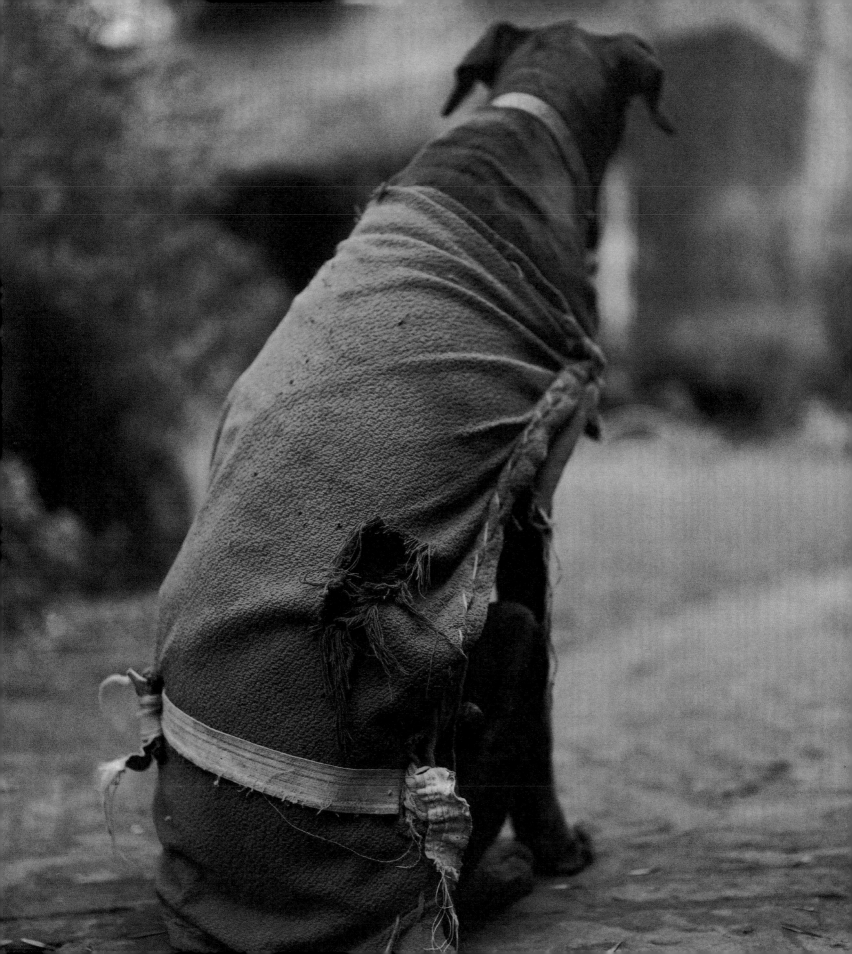

Caped Dog 1995

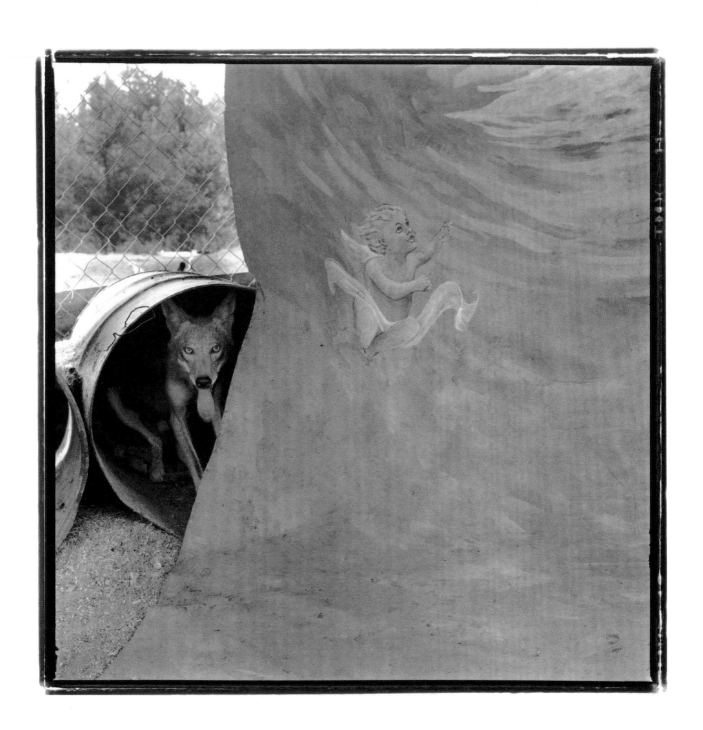

Coyote **1989**

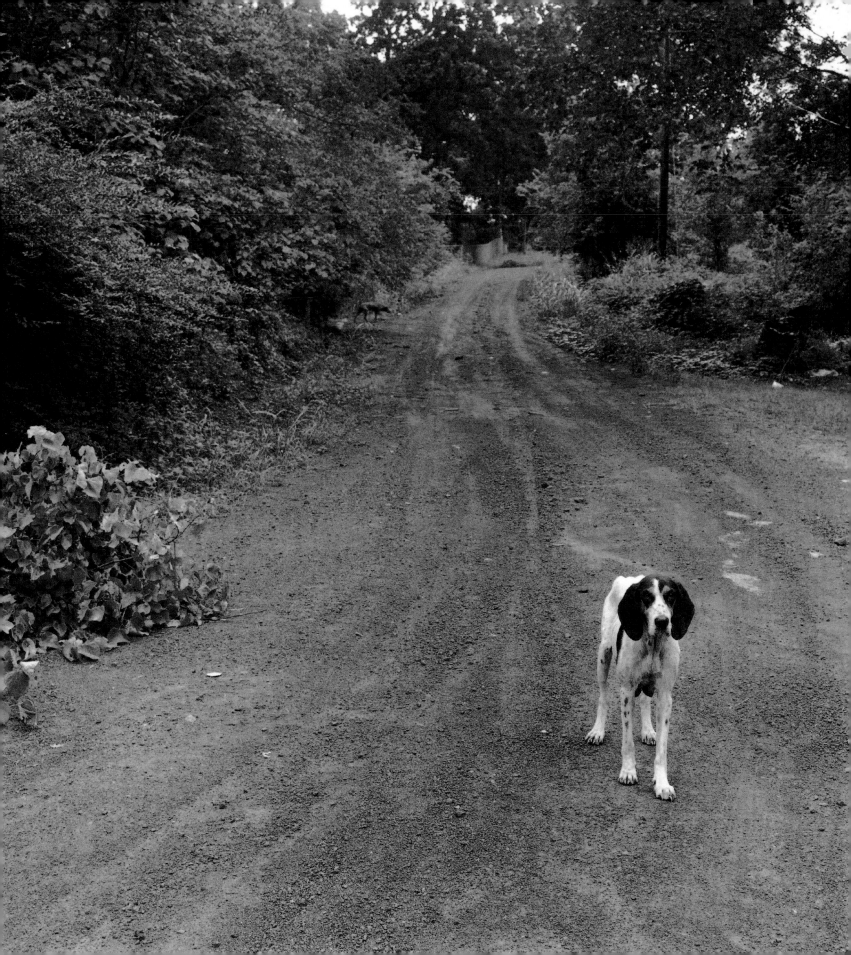

Dialville **1986**

Luna **1995**

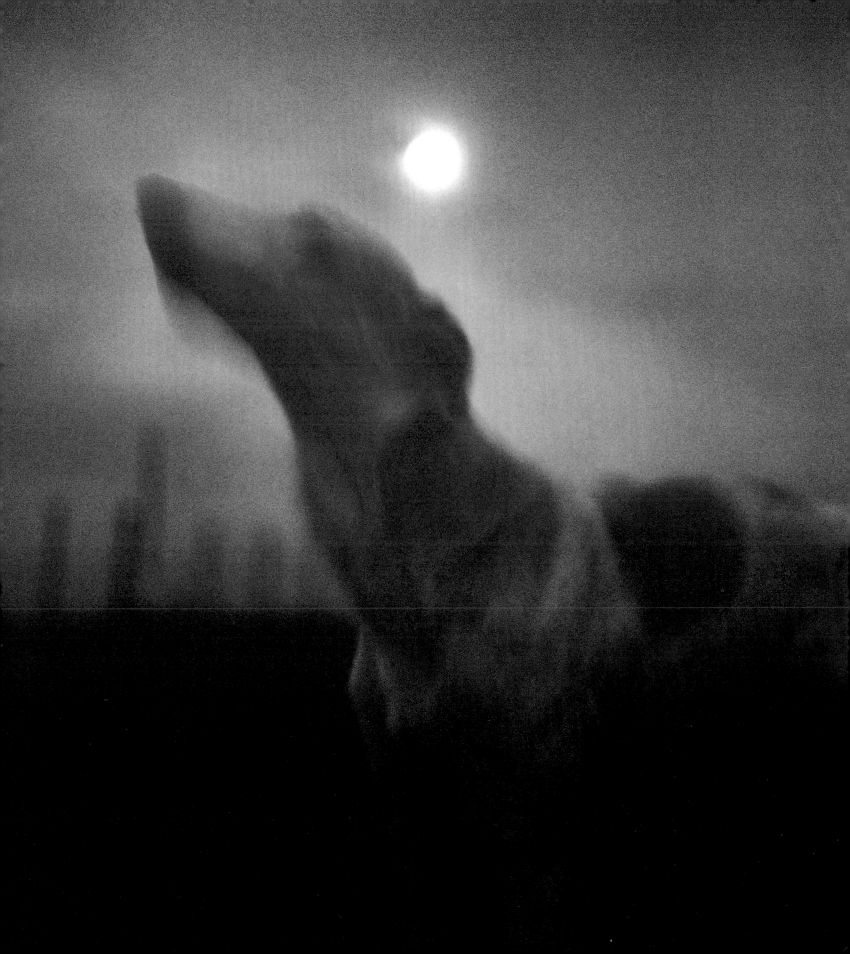

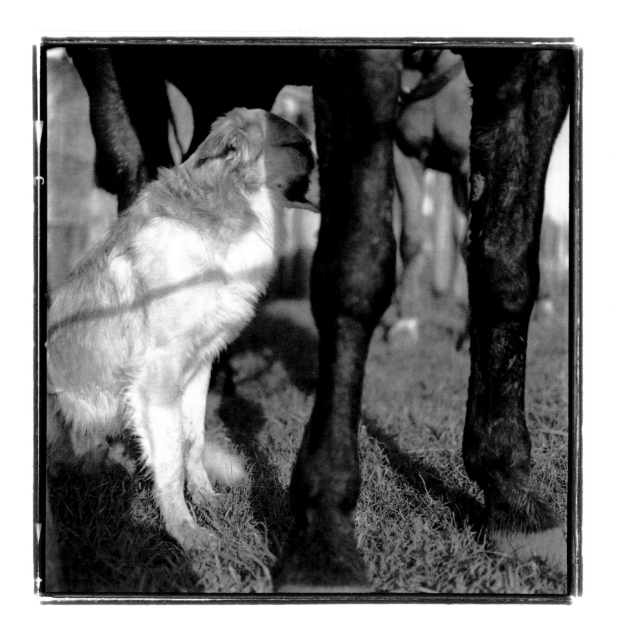

Hand and Paw **1995**

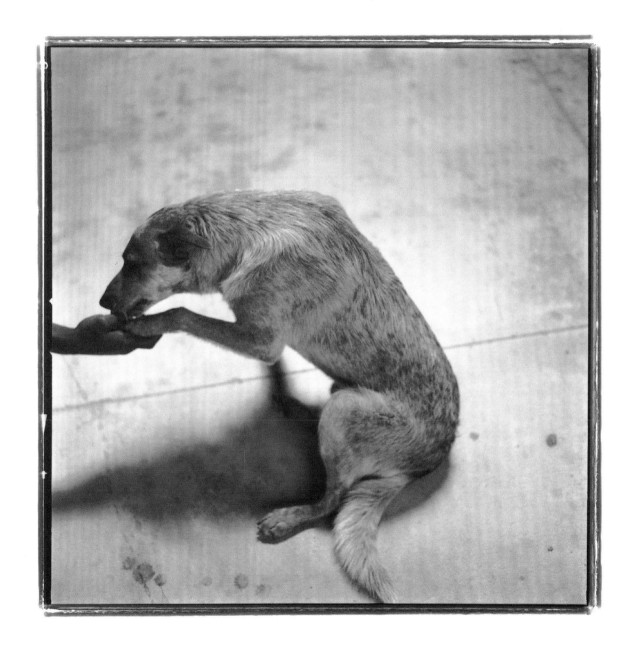

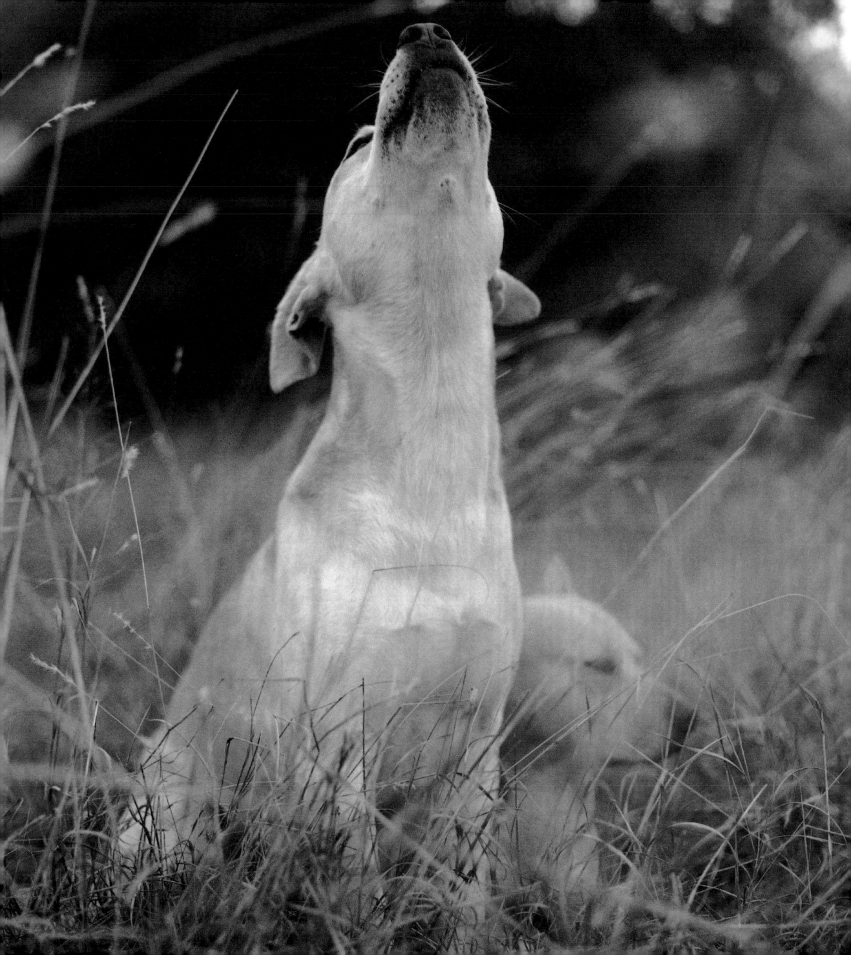

Howling **1993**

Country **1988**

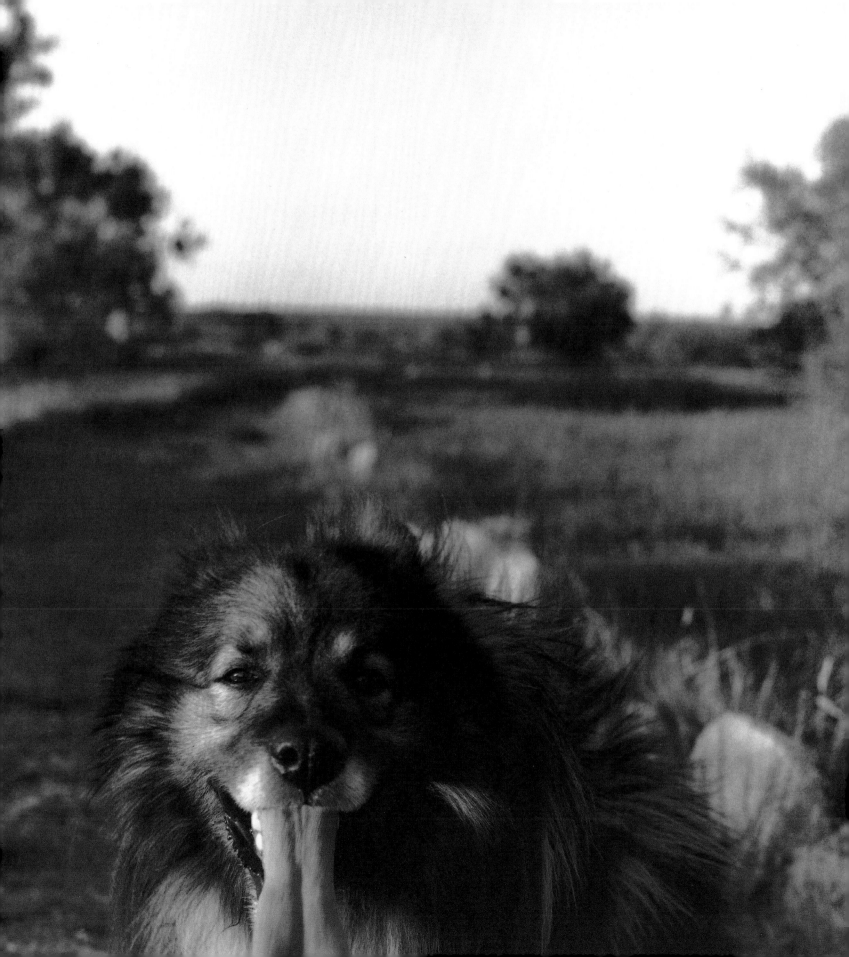

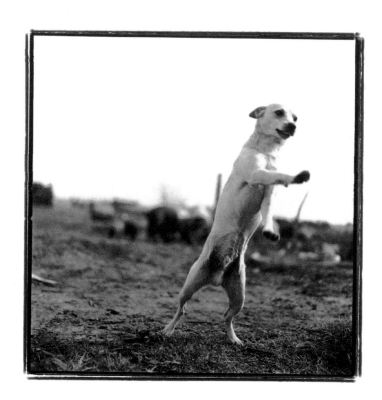

Standing Dog **1995**

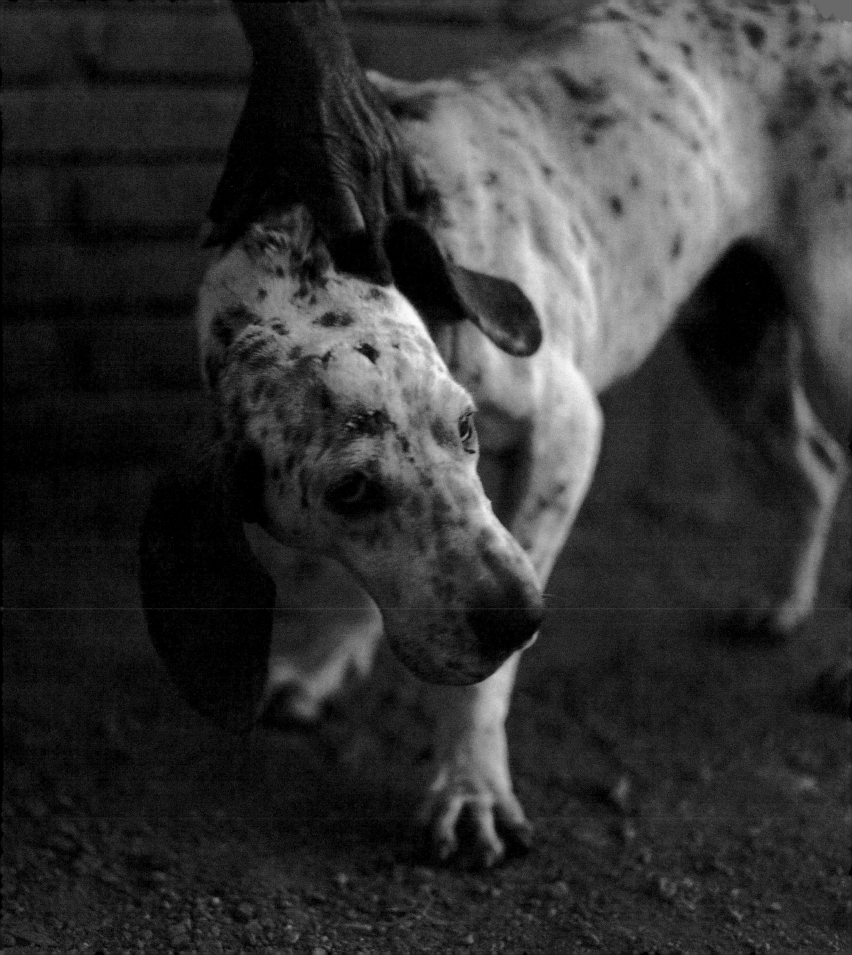

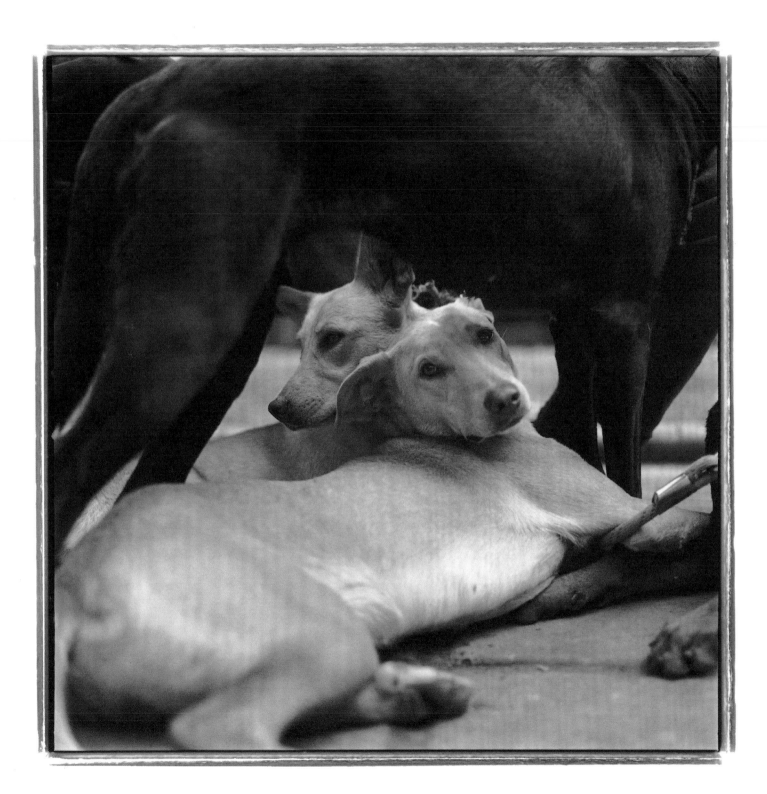

Sisters **1995**

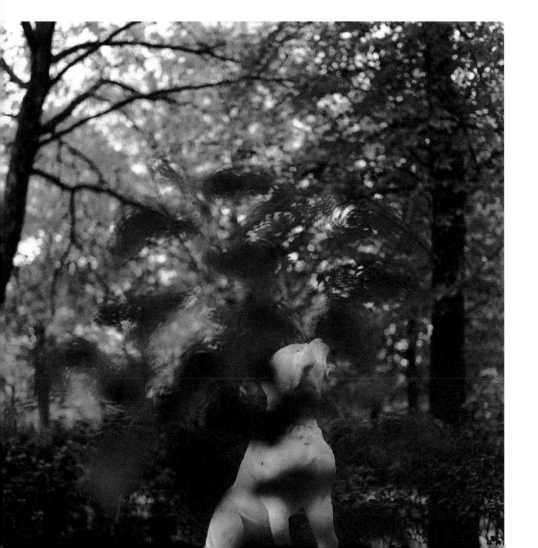

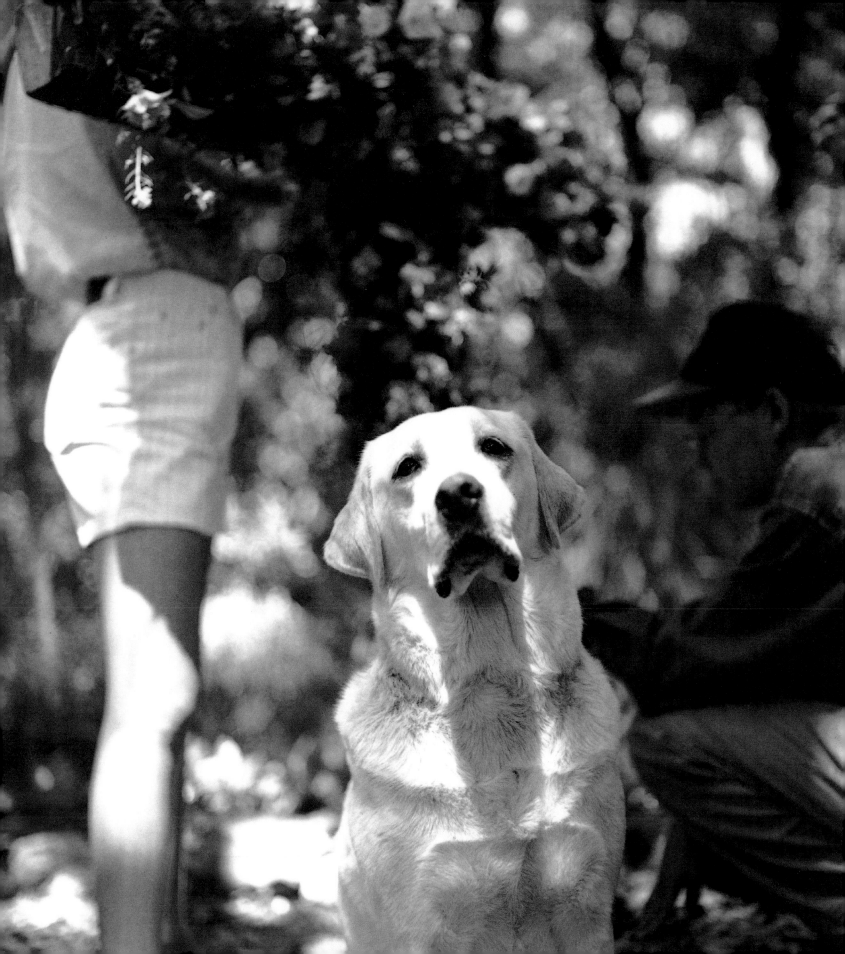

Pigs and Dogs **1990**

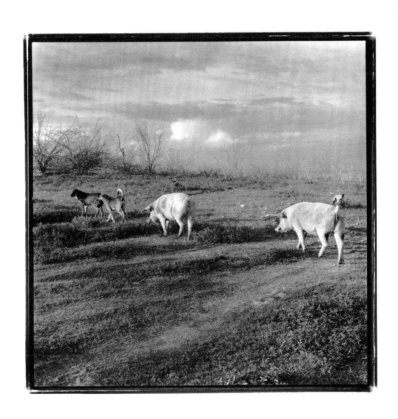

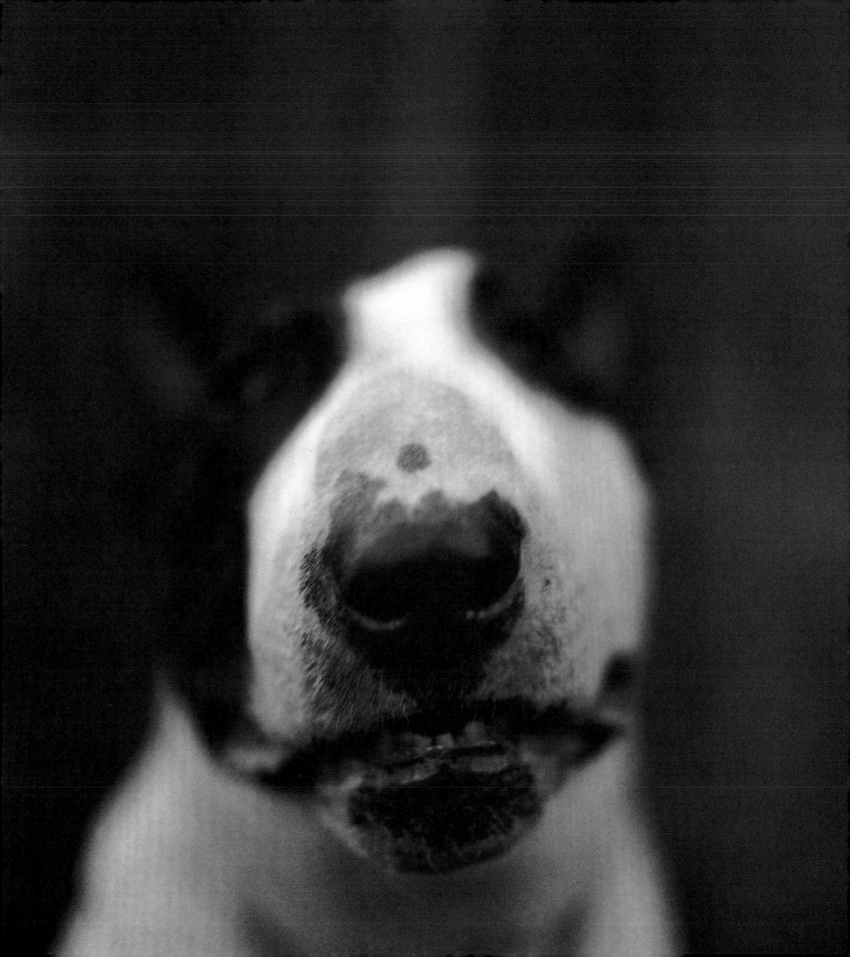

Otis **1993**

Blackeyed Dog **1990**

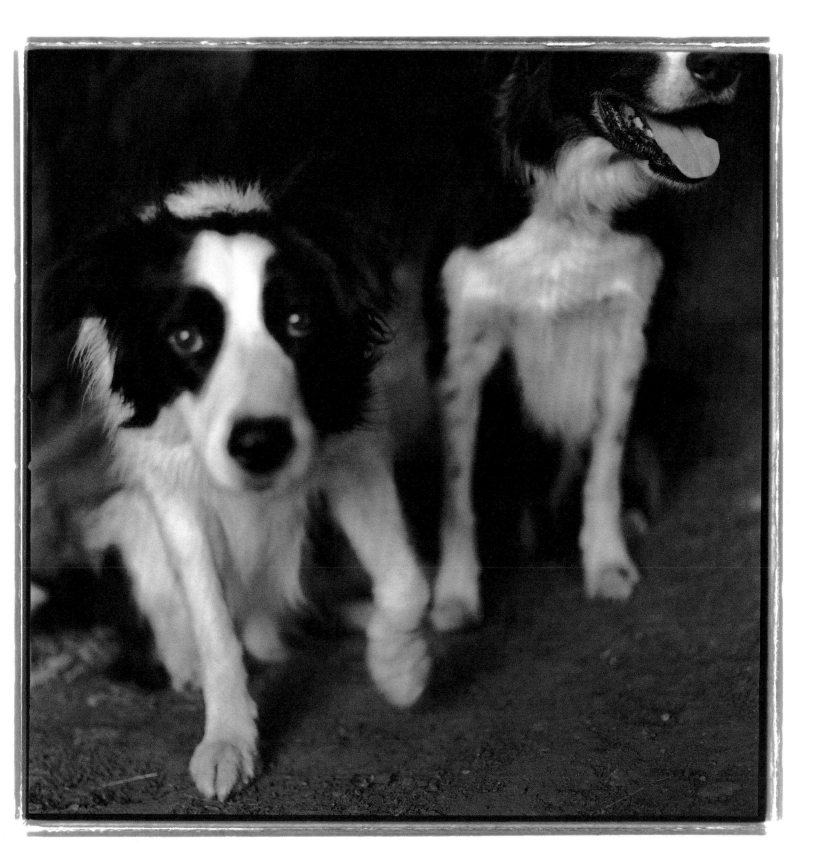

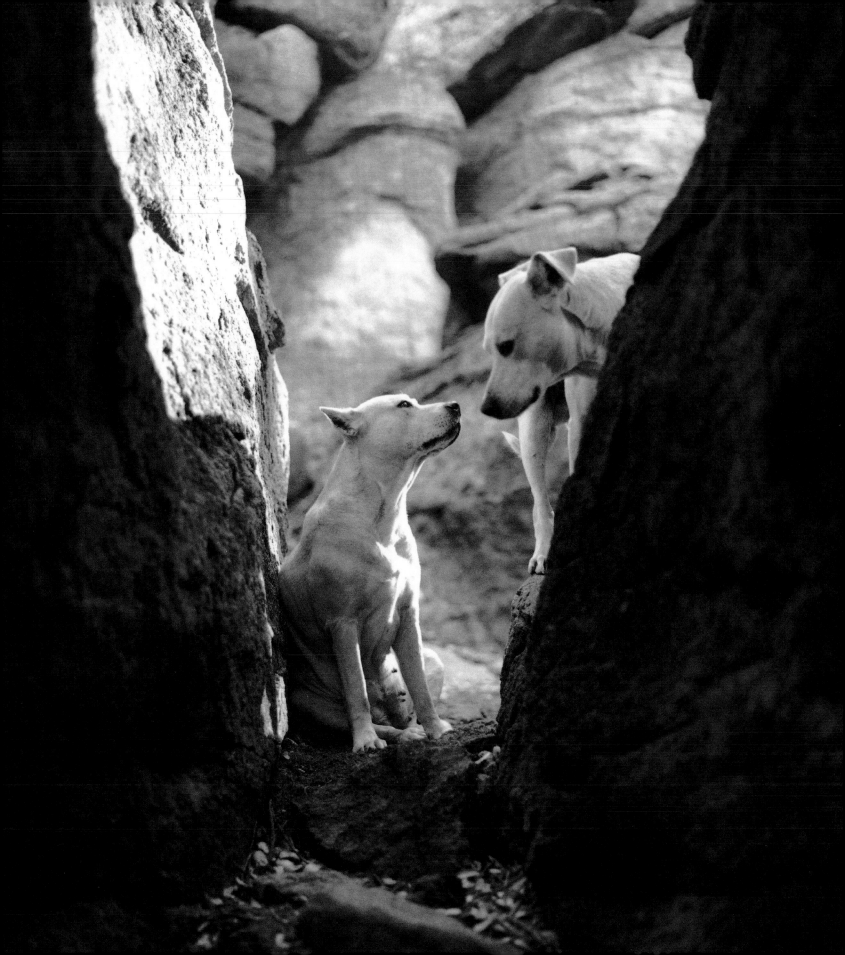

Bubba and Peggy 1993

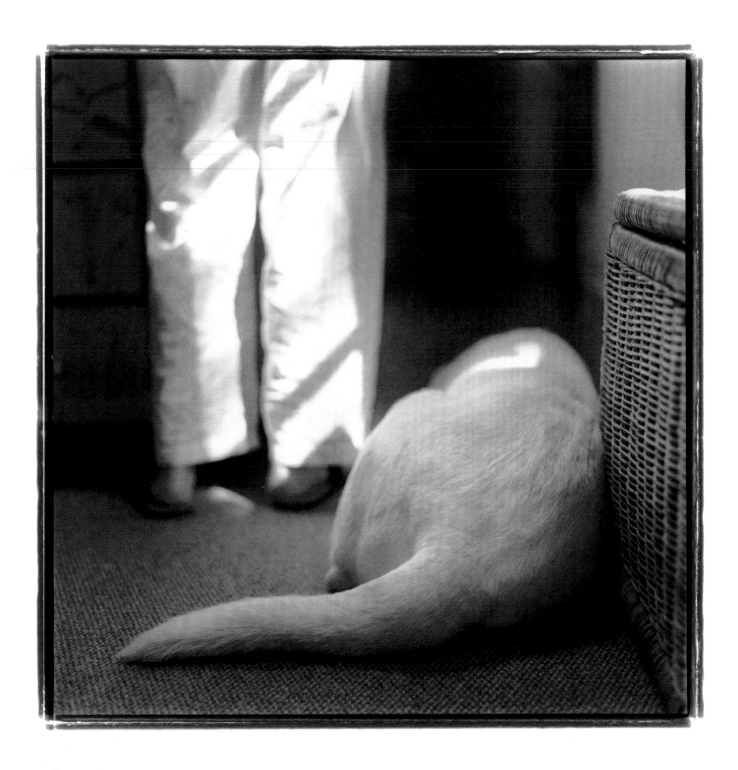

Pajama Bottoms **1995**

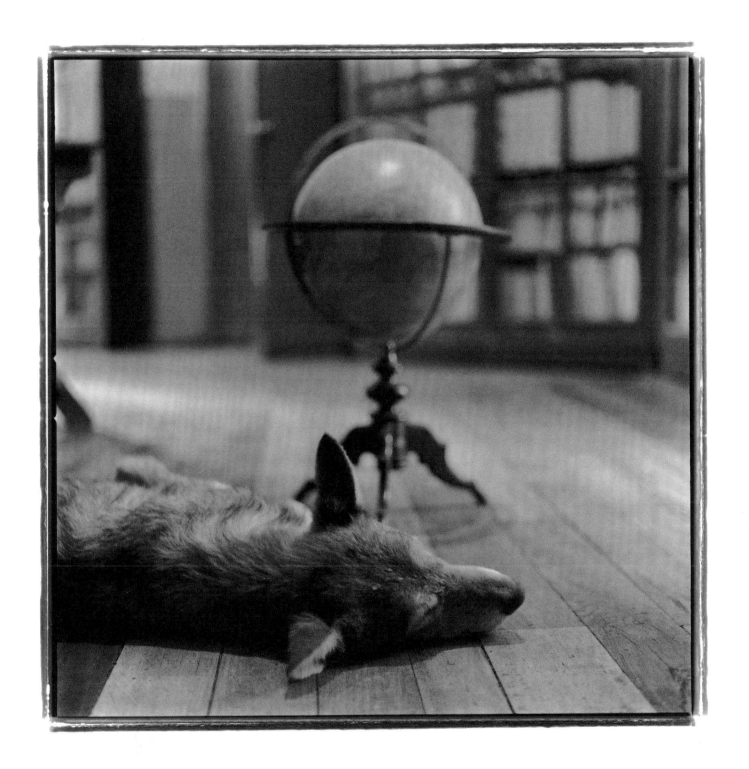

Wooden Floor **1995**

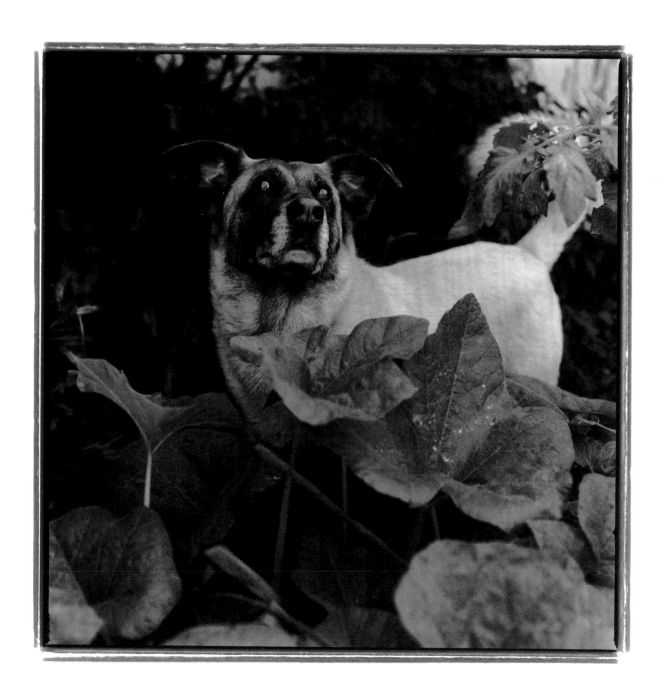

Dog Ghost **1990**

Dog and Coffin 1992

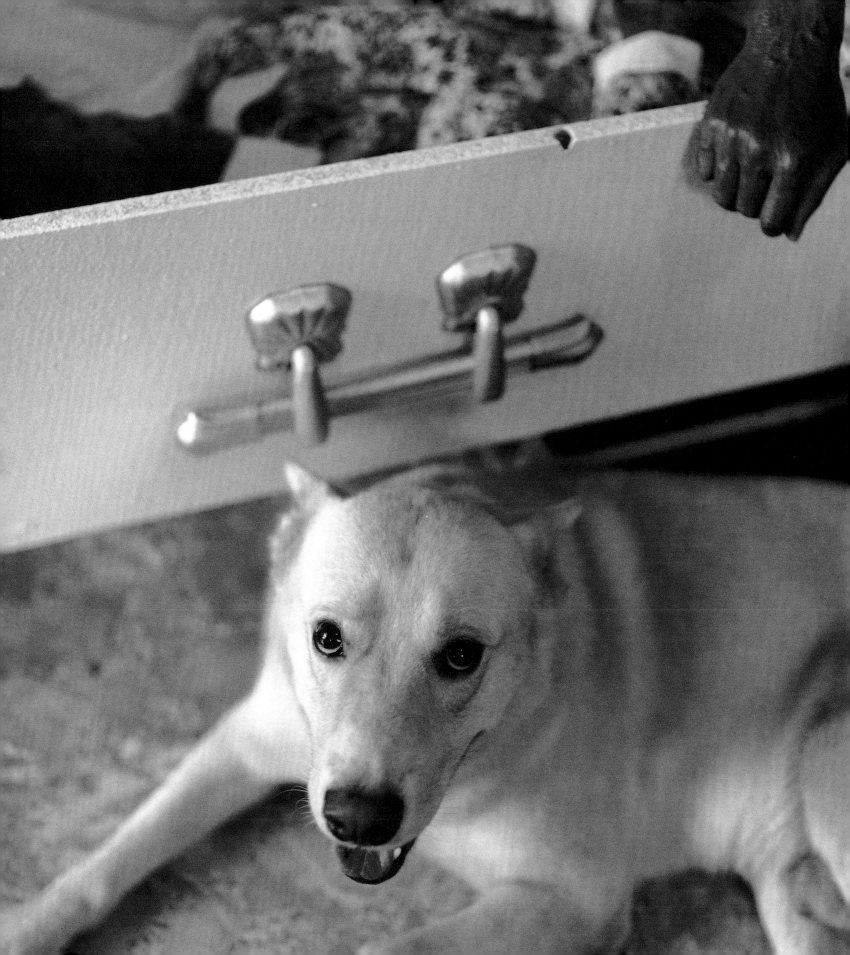

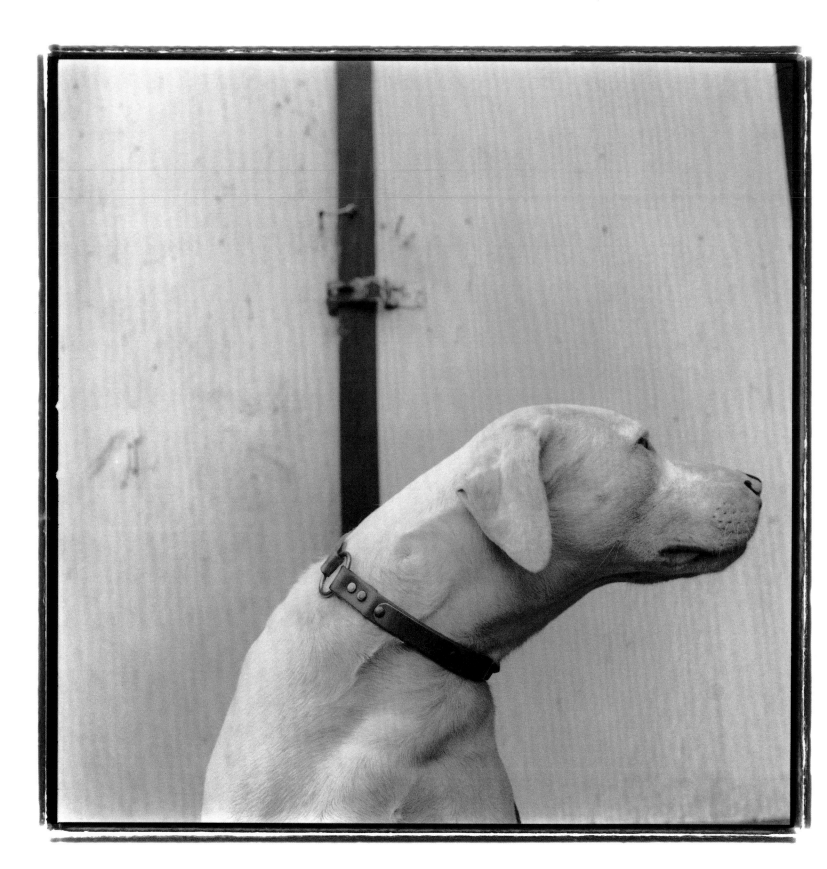

Catahoula **1990**

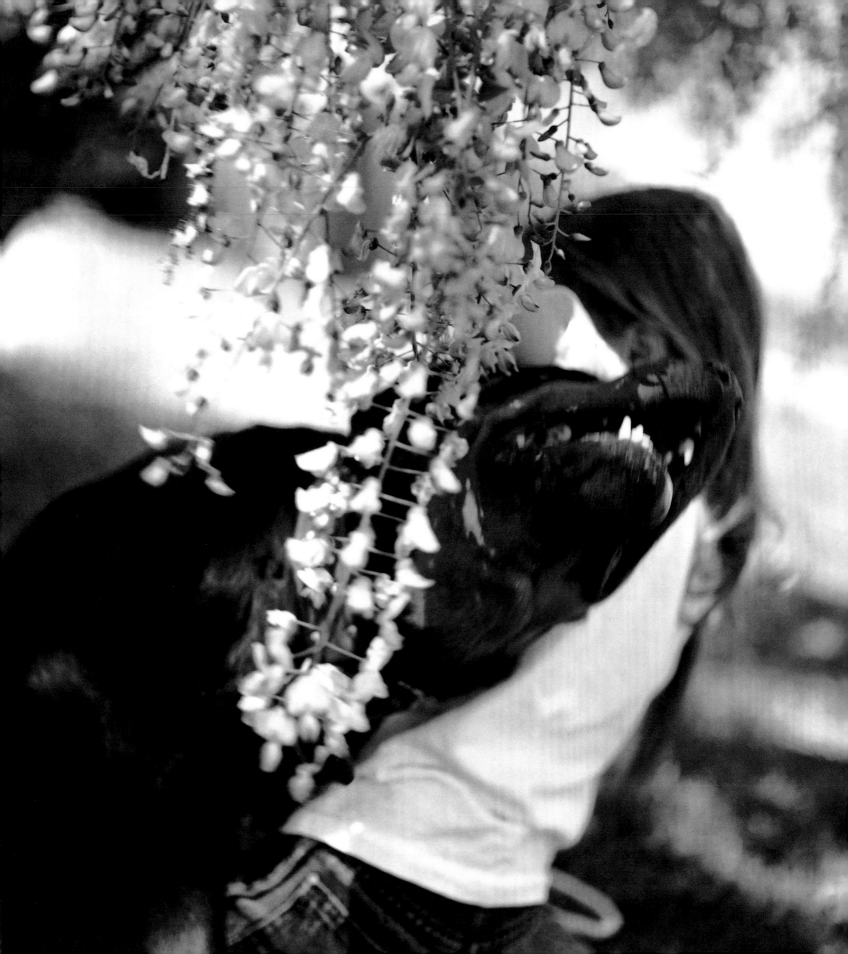

Wisteria **1995**

Spring **1995**

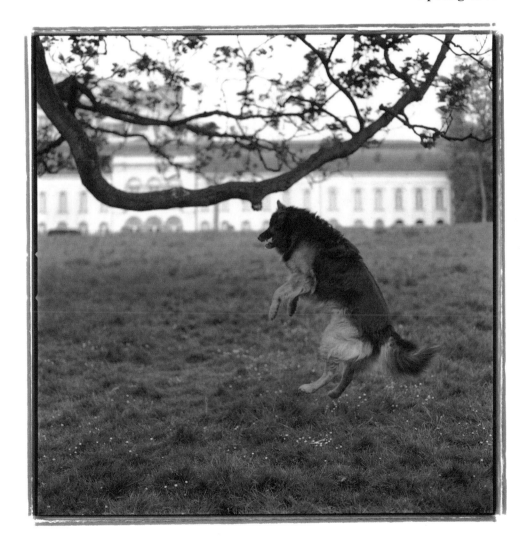

Niño **1995**

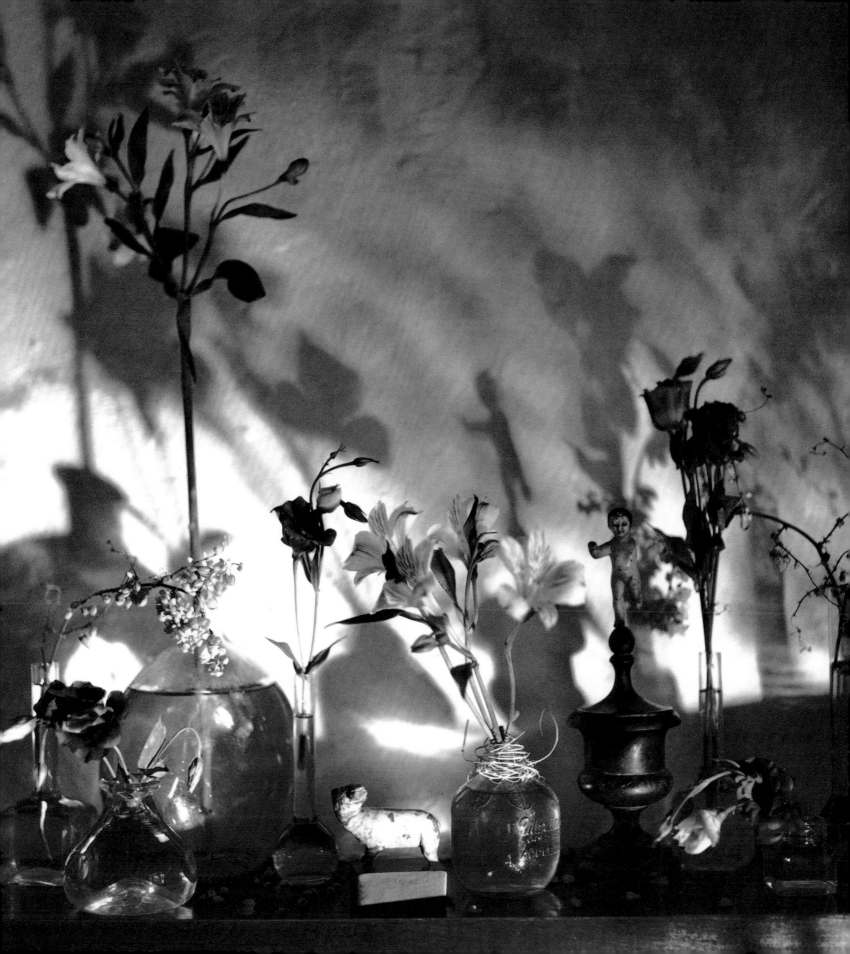

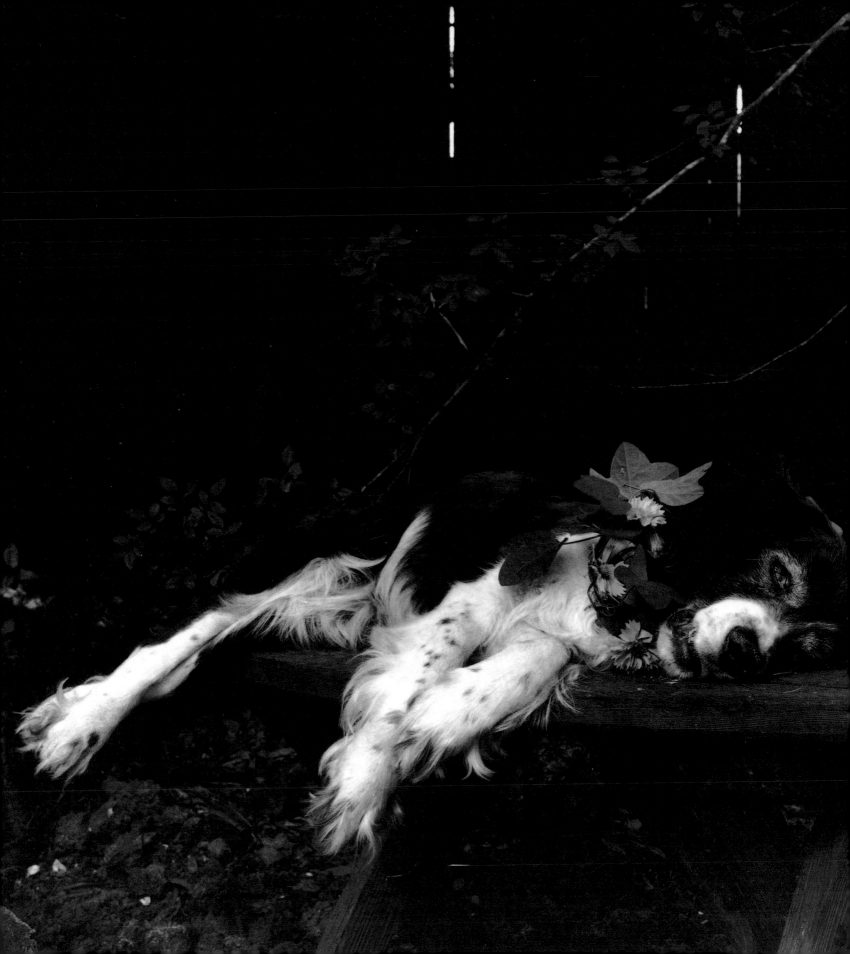

Burying Bessie **1991**

Dog in Church **1994**

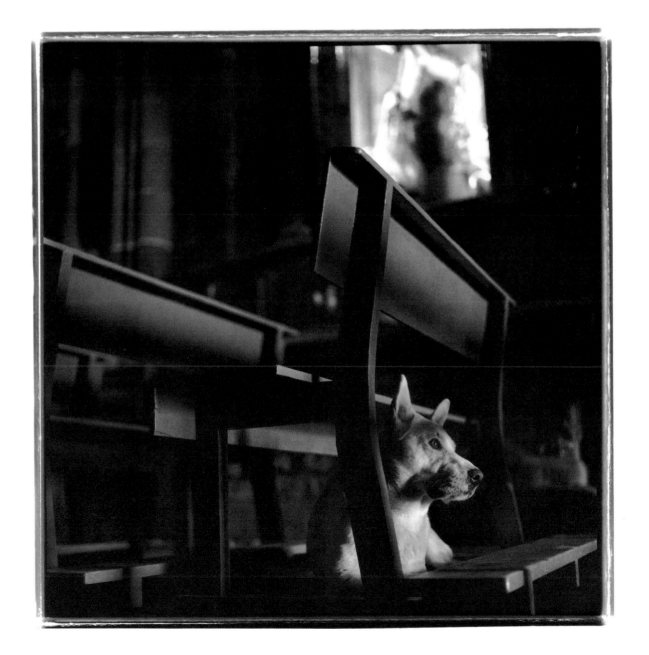

Bronze **1995**

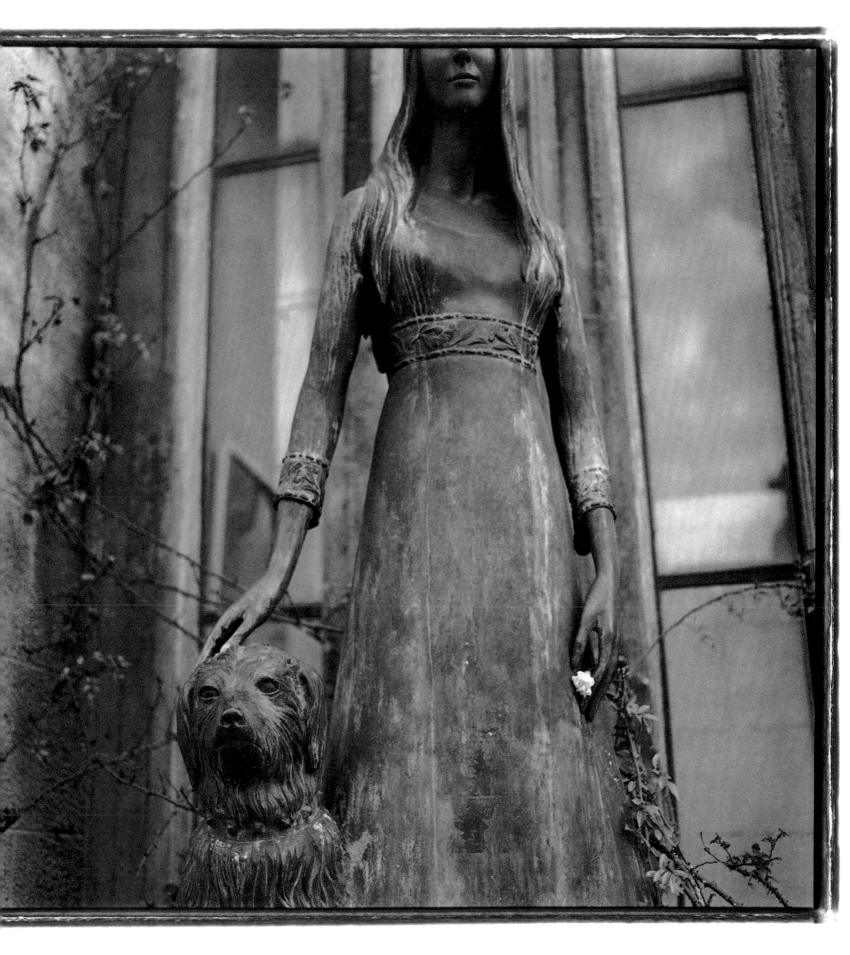

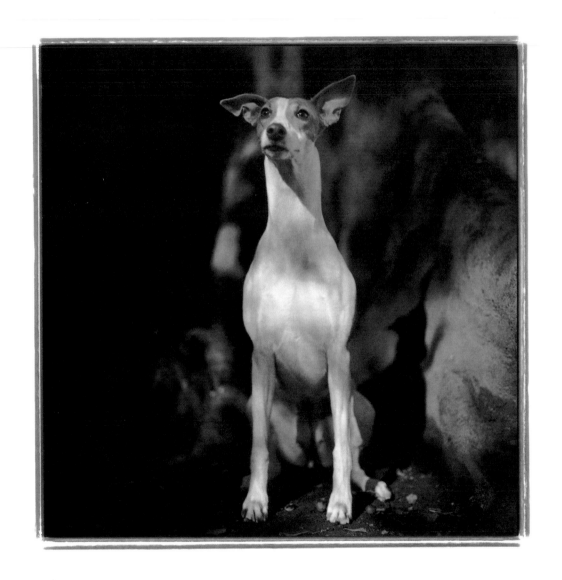

Elena **1995**

Dog Beach **1995**

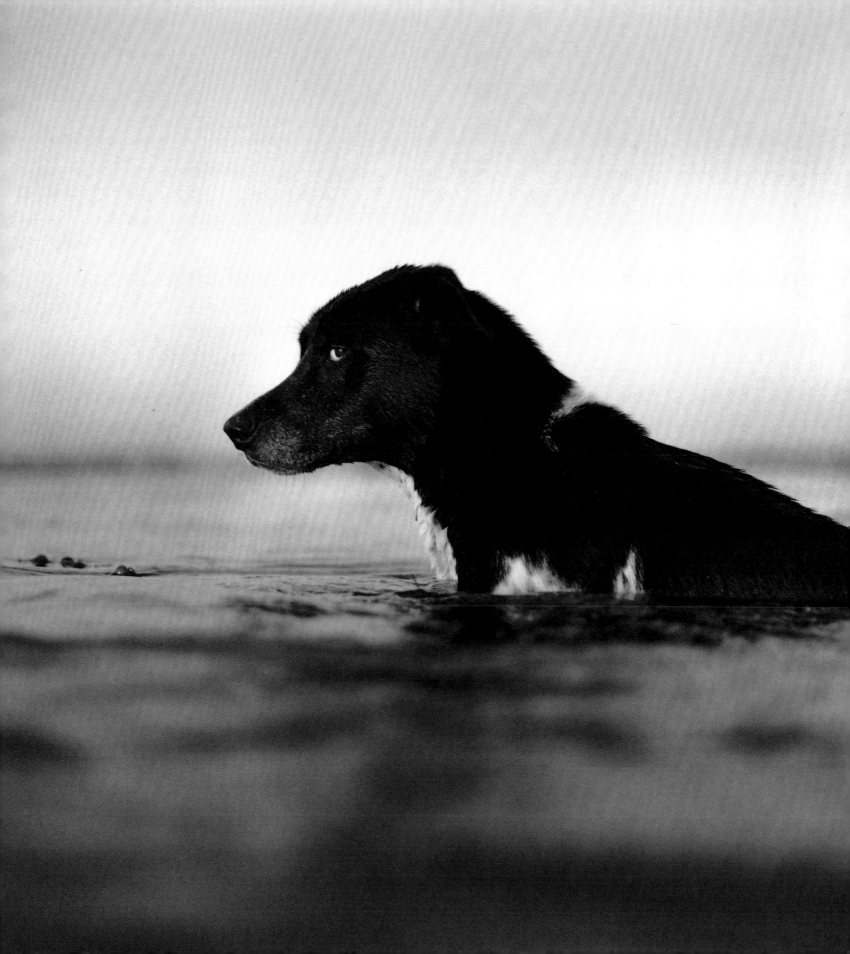

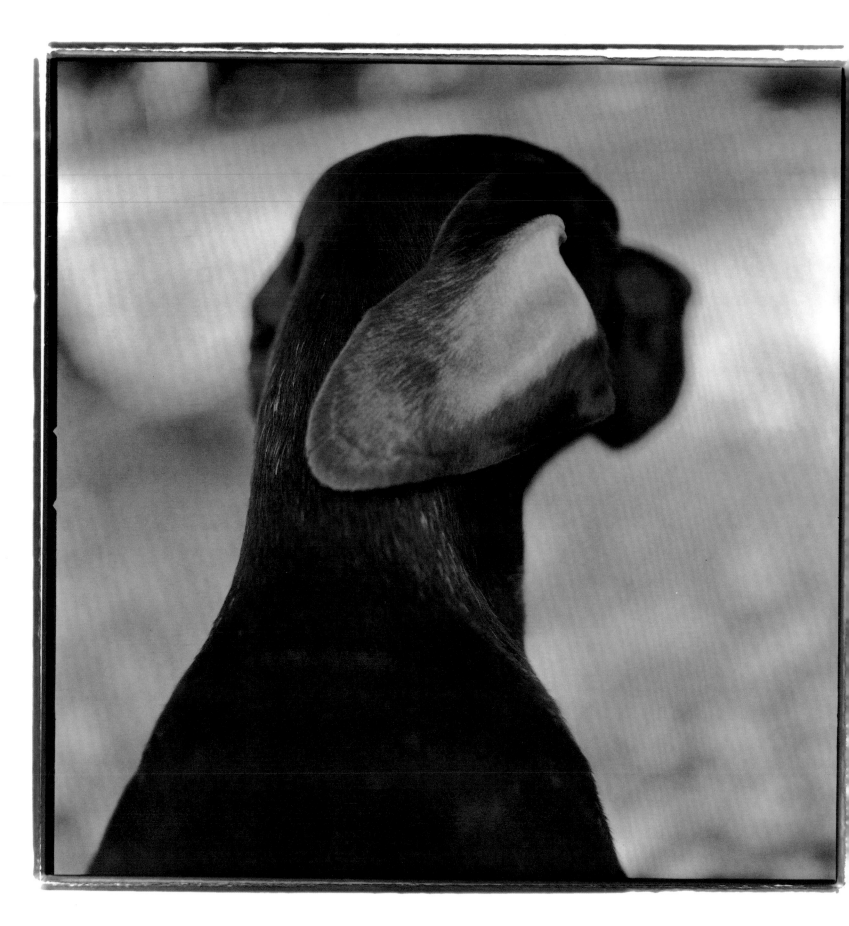

Short Hair **1995**

Radar **1995**

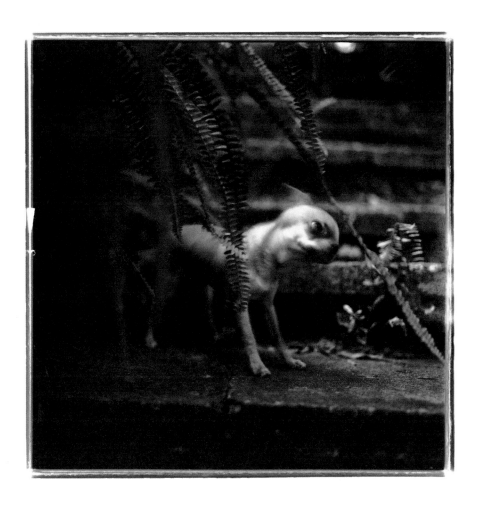

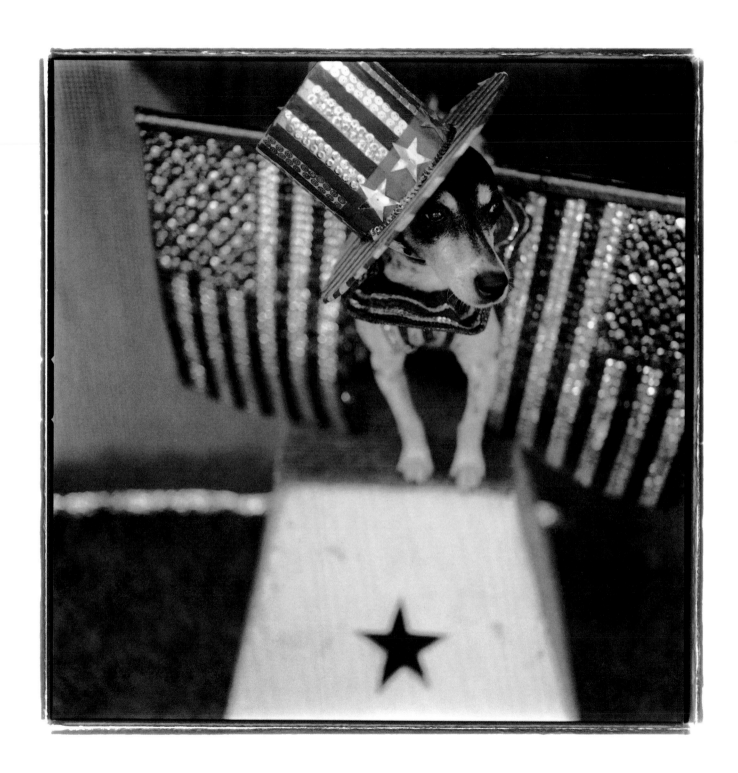

Stars and Stripes **1995**

Julius **1995**

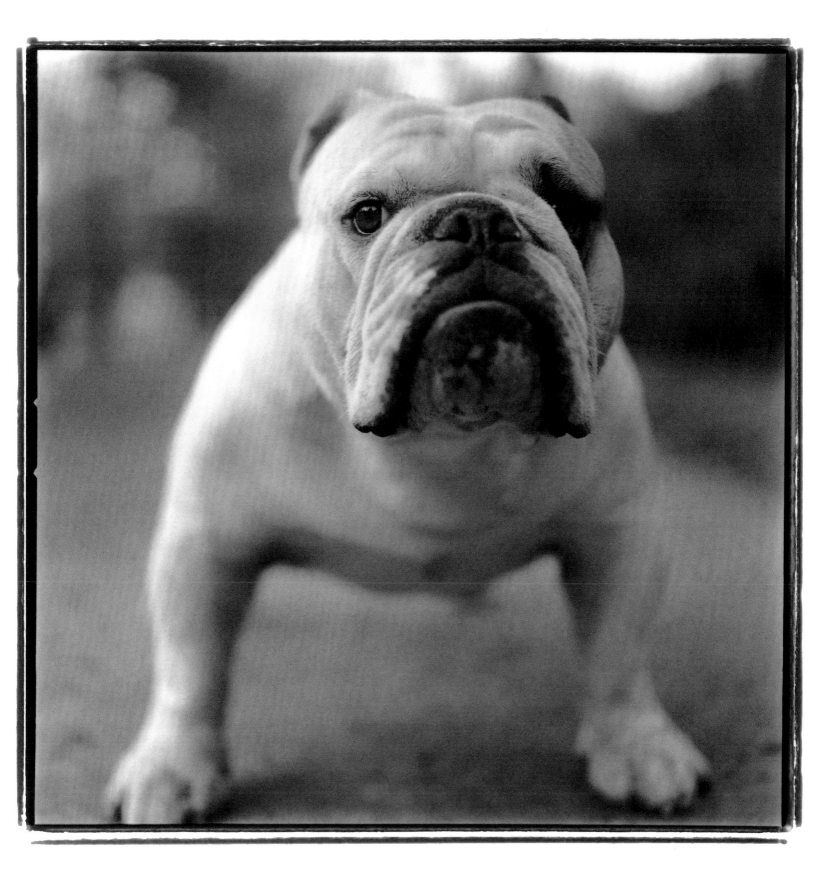

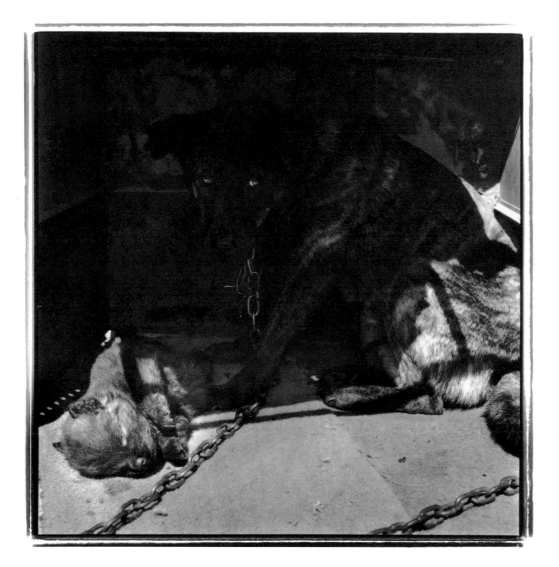

Weeping Mary **1995**

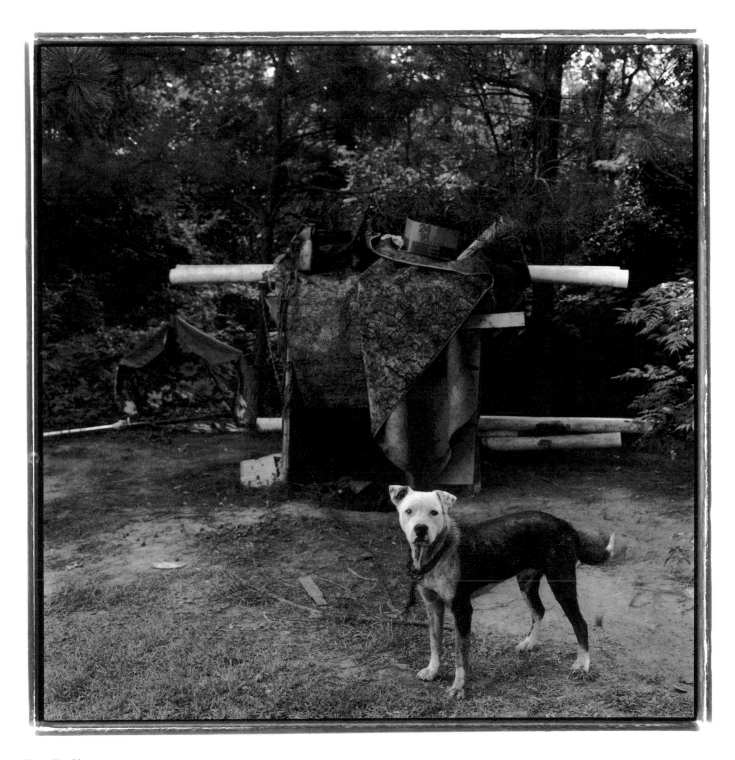

Pit Bull 1987

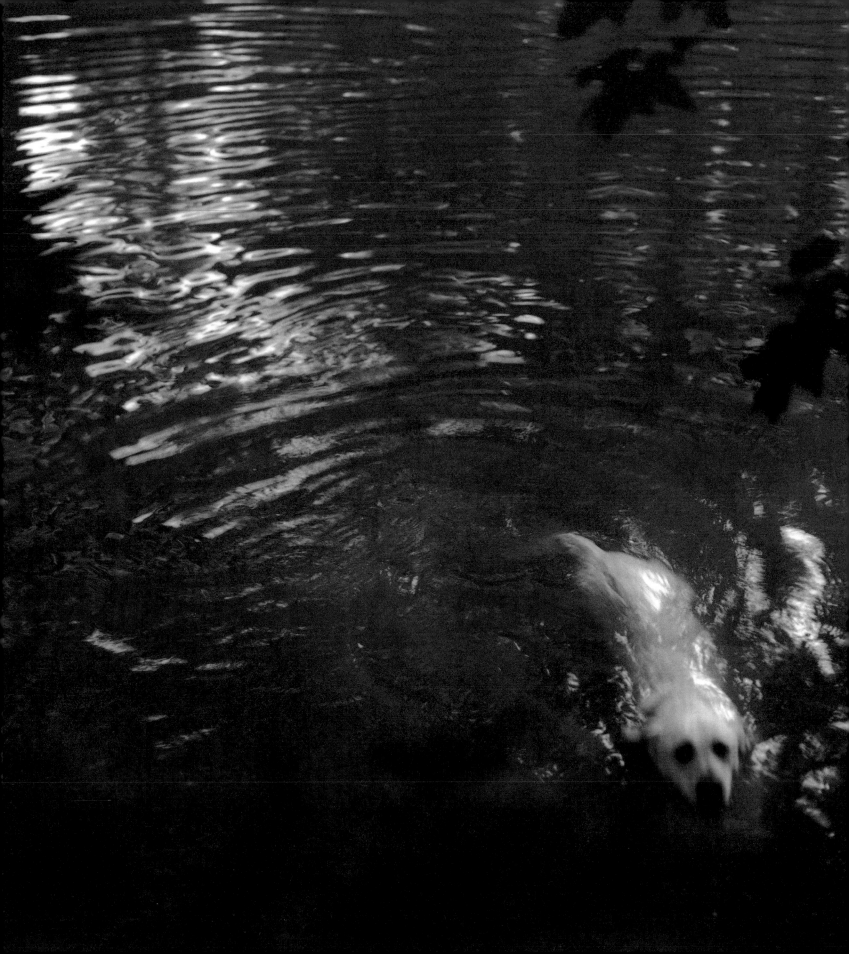

Black water 1993

Rose **1995**

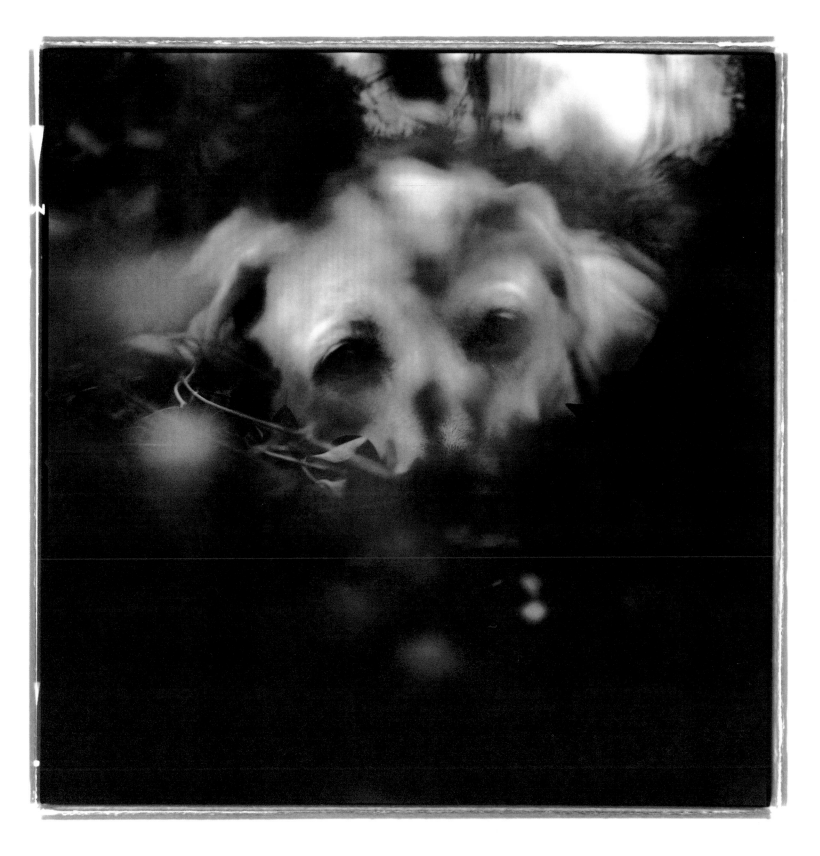

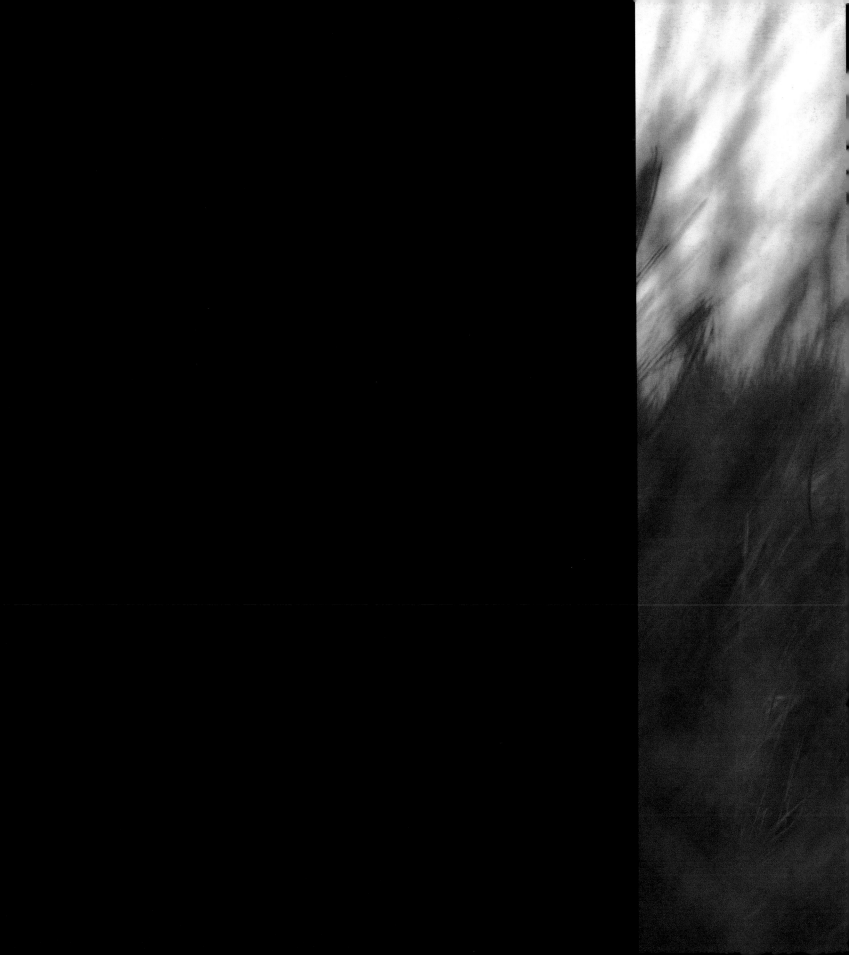

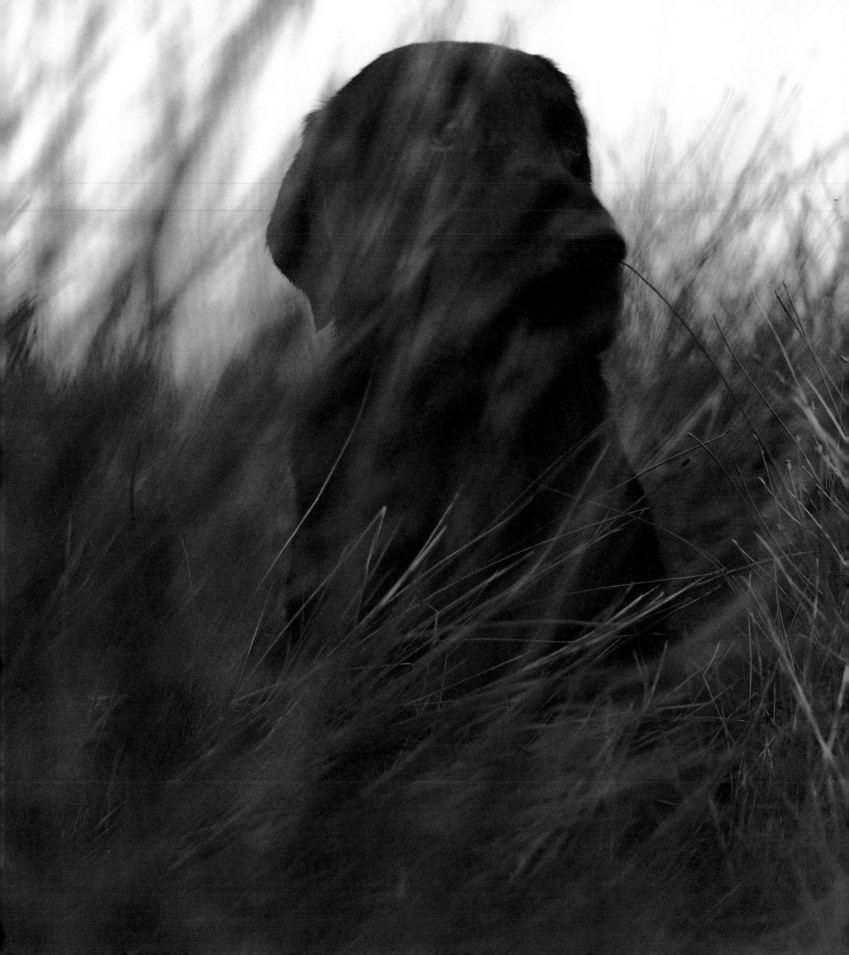

Marsh **1995**

Checkered Floor **1995**

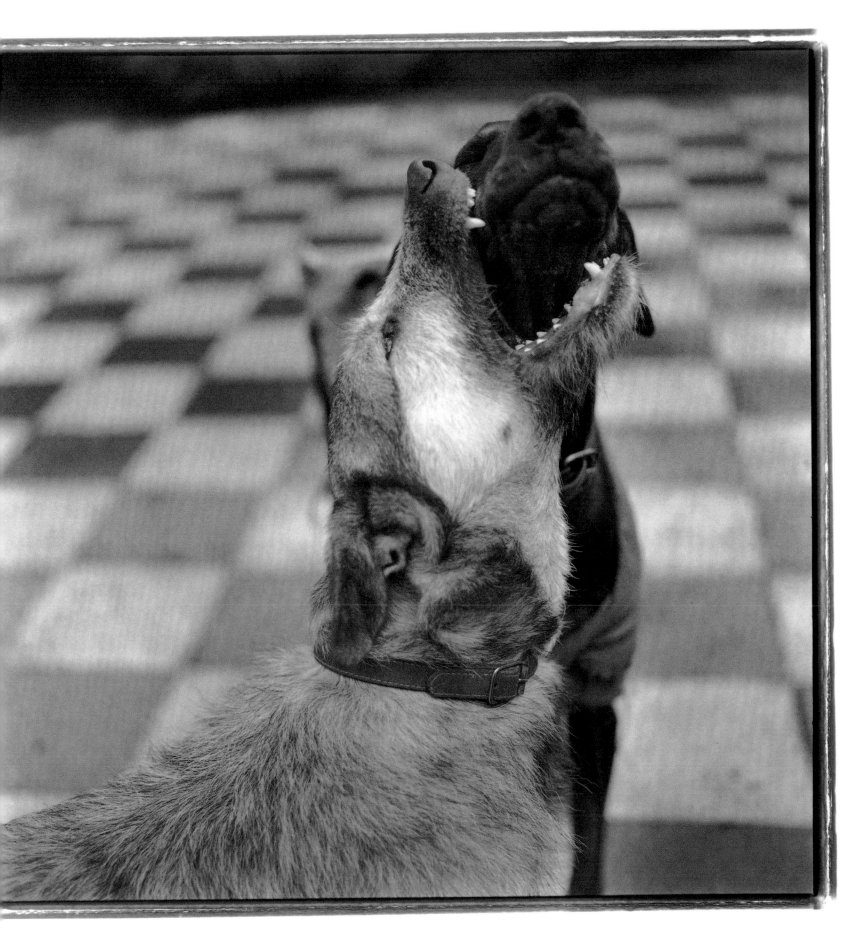

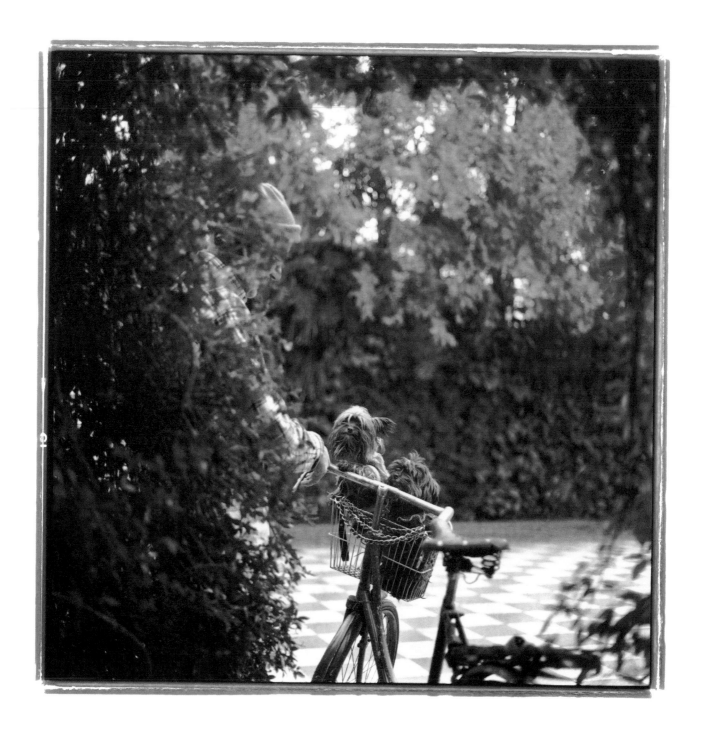

Basket **1995**

Chained 1995

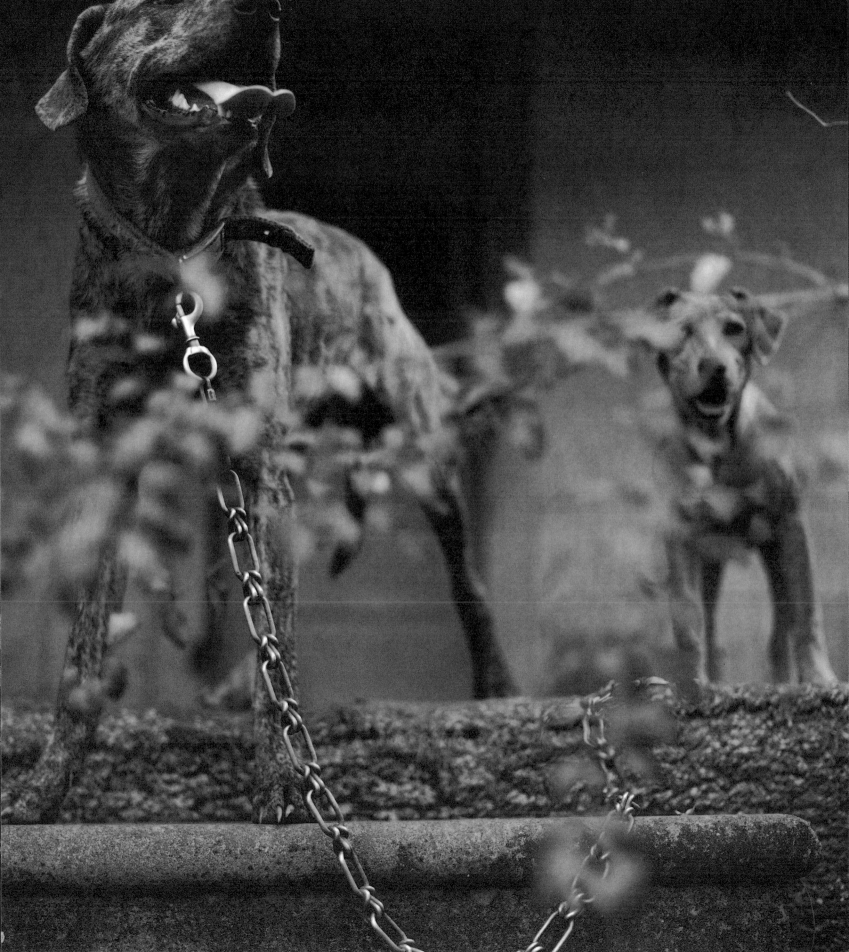

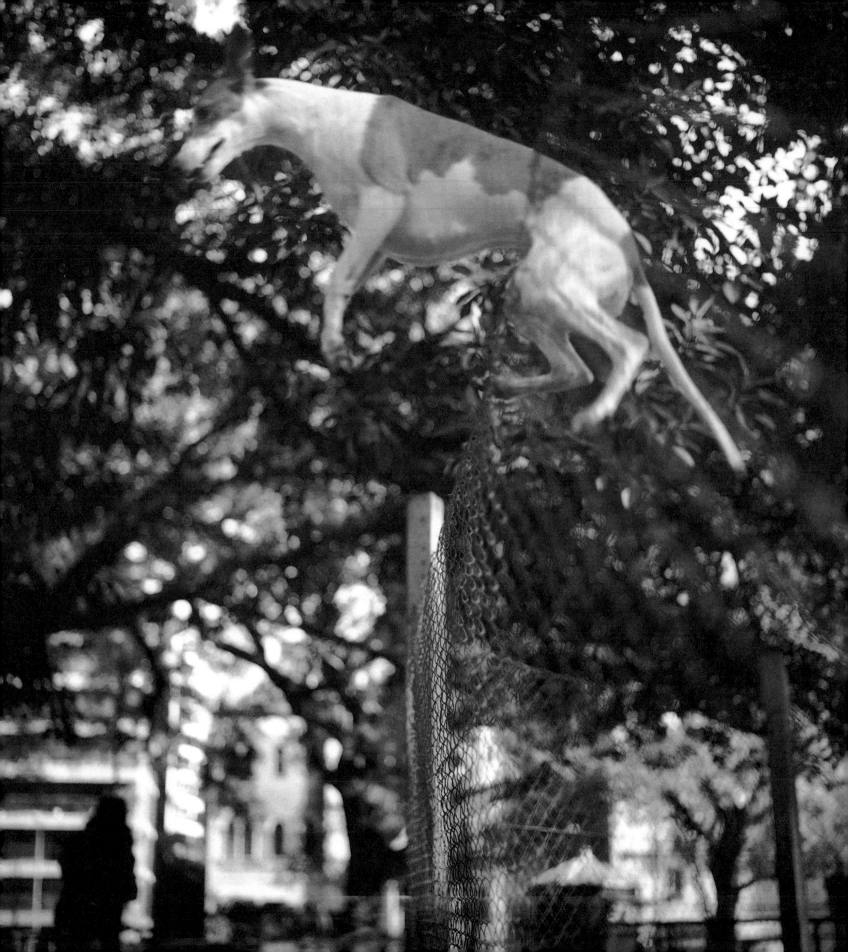

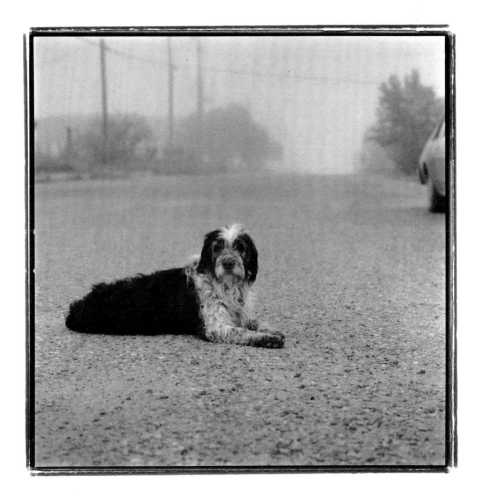

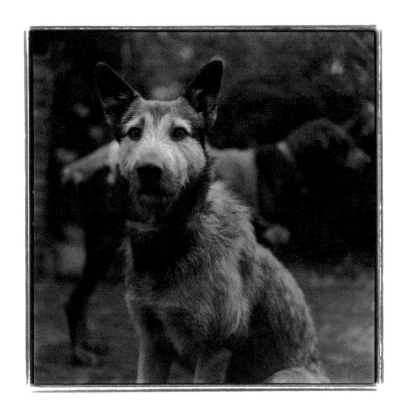

Bear **1995**

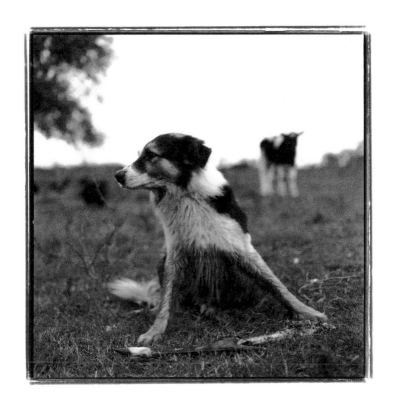

Deer Leg **1995**

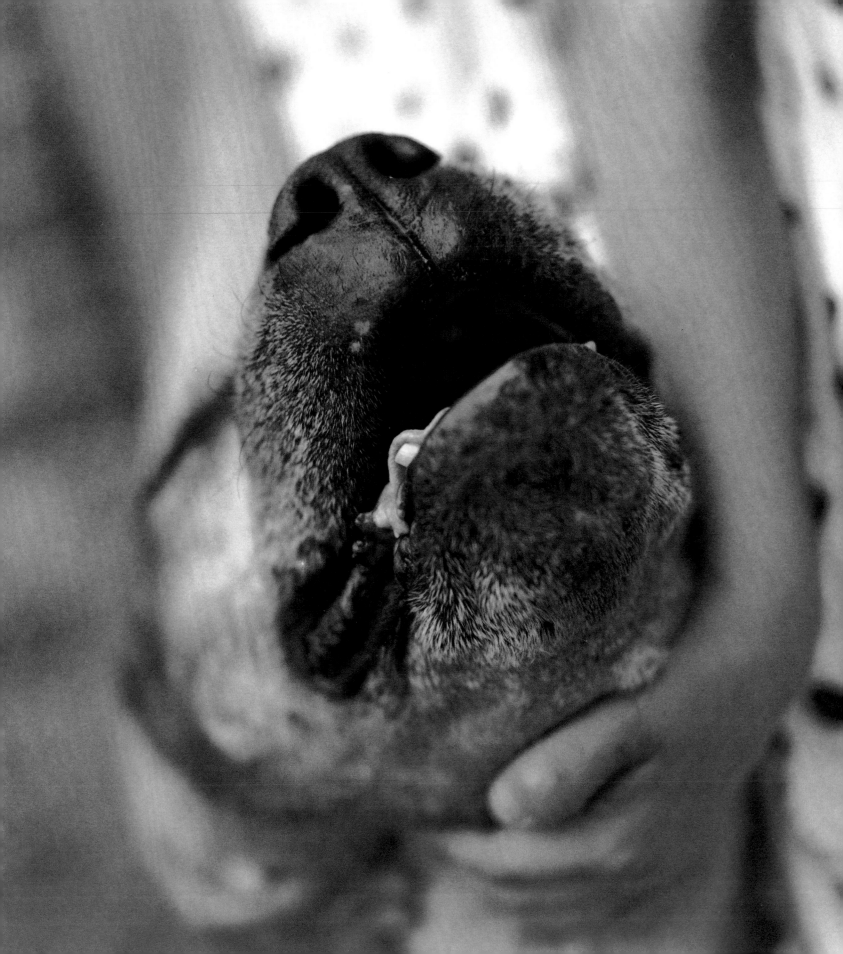

Spotted Dress **1992**

Lost Dog **1992**

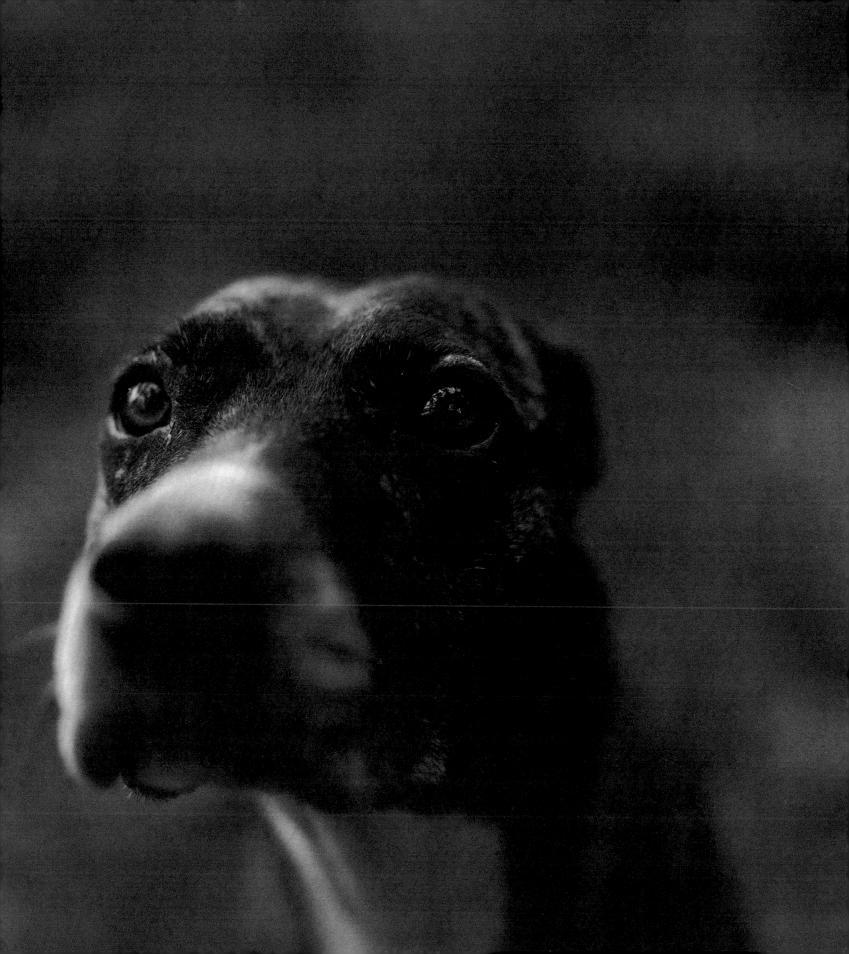

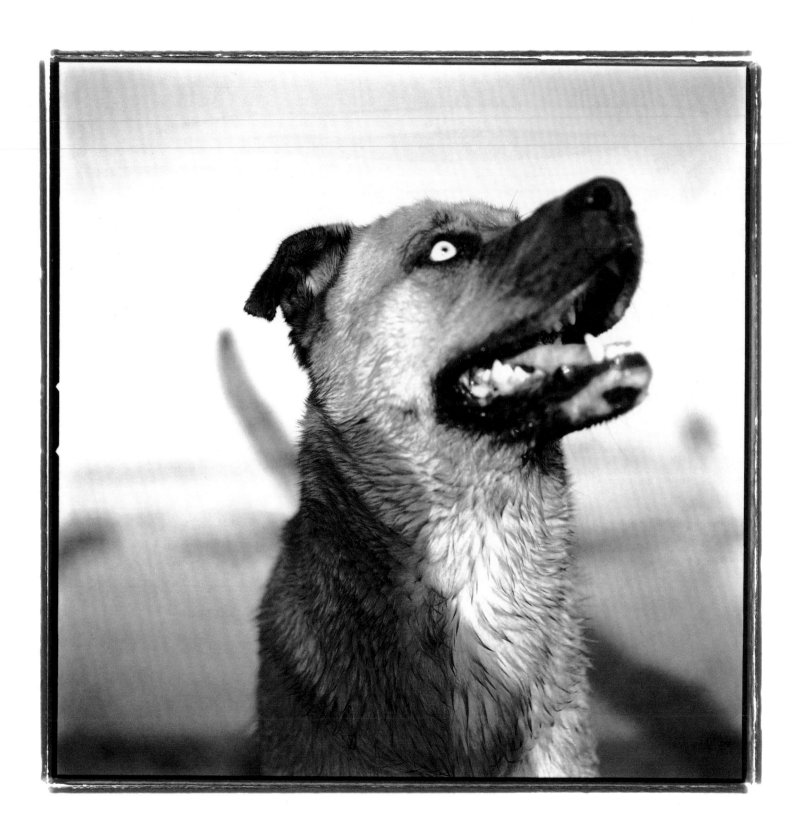

Blue-Eyed Dog **1995**

Blind **1995**

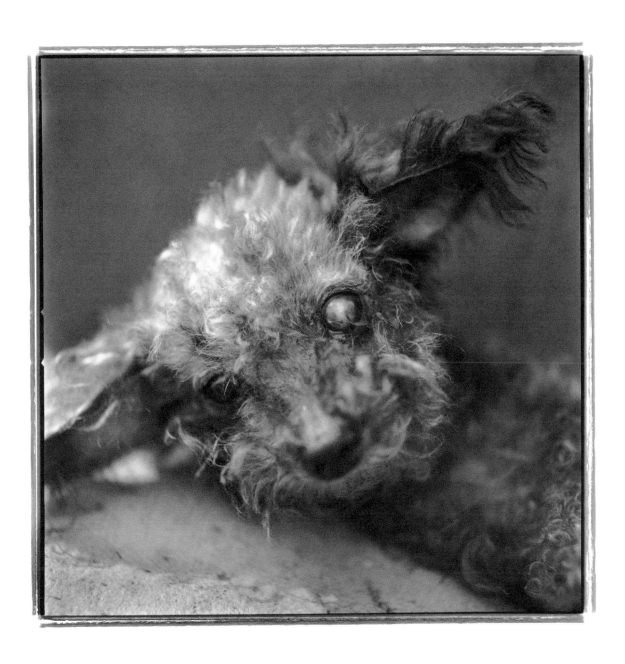